BREWING IN NOTTINGHAMSHIRE

KEITH OSBORNE

AMBERLEY

First published 2016

Amberley Publishing
The Hill, Stroud
Gloucestershire, GL5 4EP

www.amberley-books.com

Copyright © Keith Osborne, 2016
Maps contain Ordnance Survey data.
Crown Copyright and database right, 2016

The right of Keith Osborne to be identified as
the Author of this work has been asserted in
accordance with the Copyrights, Designs and
Patents Act 1988.

ISBN 978 1 4456 6107 0 (print)
ISBN 978 1 4456 6108 7 (ebook)

British Library Cataloguing in Publication Data.
A catalogue record for this book is available from
the British Library.

Typesetting by Amberley Publishing.
Printed in the UK.

Contents

Introduction

For hundreds of years, Nottingham – and its county – has enjoyed a reputation for brewing good ale. The diarist Samuel Pepys referred to ales from Nottingham and other localities being sold in London at the end of the seventeenth century. Another diarist, traveller Celia Fiennes, observed that the 'good ale of Nottingham' was 'the best of all liquors'; she tasted, at Newark, 'the strongest and best Nottingham ale that looked very pale but exceedingly clear'. Colonel Robert Walpole MP indicated, in 1690, that he drank Nottingham ale regularly when attending London for his parliamentary duties.

Nottingham ale was famous for two reasons. The area was linked – as was Derby – with the success of Burton-on-Trent. The valley of the Trent, with its geological strata, makes the water especially suitable for brewing. The water below Nottingham, while not matching exactly the quality of Burton, still gave rise to fine ales, sold in bottles at a higher price than standard London beers – and to a fashionable market. Stukeley called Nottingham ale 'highly valued for softness and pleasant taste'. Nottingham ale was evidently judged in a class of its own; Defoe praised it without mentioning Burton.

The ancient rock-hewn caves below the city and the locality were also ideal for the storage and fermentation of ale. Formed from the soft red sandstone, they were deep and cool and allowed ale to be kept at a constant temperature.

The proximity of barley-growing areas also helped. All factors combined to give Nottinghamshire ale an unrivalled reputation – reflected in rhyme and song. Mr Gunthorpe, a naval officer, composed a poem about its virtues:

Nottingham ale, boys, Nottingham ale
No liquor on earth is like Nottingham ale...
It expels every vapour, saves pen, ink and paper...
It will open your throats, you may preach without notes
When inspired by a bumper of Nottingham ale.

This book outlines the famous breweries in both city and county that promoted the reputation of Nottingham ale, dominating the brewing scene until comparatively recently. It also covers some of the smaller breweries that existed in Nottinghamshire, especially the pubs that had breweries attached (the home-brew houses), but cannot include them all; and, finally, features all the modern microbreweries – some now defunct, but others still thriving – that continue the legend of Nottingham ale.

Early Brewers

Nottingham

Information about early brewing in Nottingham is sparse. *The Universal British Directory* issued before 1800 listed only two brewers – Alexander Green & Co., site of Poplar Place, and Thomas Simpson, Goose Gate.

Glover's Directory 1825 showed:

James Cordley, Clare Street
Robert Davison, Cross Lane
James Turner, Marquis of Anglesea, St. James Street

Other breweries featuring in trade directories of the mid-1800s were:

Robert Birkley, Chapel Bar (1835–40 – and Leicester)
Byng's Brewery, Sheep Lane (1840)
Samuel Deverill, Bridge Street (at Pelham Street Brewery 1832–1835, trading as Samuel Deverill & Co. By 1840, Richard Parsons was running the business. It had gone by 1858.

CARRINGTON BREWERY,
NEAR NOTTINGHAM.

MESSRS. BEASLEY & CHAMPION,

Beg most respectfully to inform the Gentry and Inhabitants of Nottingham and its Vicinity, they have constantly on hand a large quantity of fine PALE ALES and SUPERIOR PORTER, which they can confidently recommend for flavor, purity and strength.

Any orders they may be favoured with will be punctually attended to.

COUNTING HOUSE, ATKIN'S YARD,
SOUTH PARADE.

Advert, 1840.

William Wright Heanley, Standard Hill (1854)

Samuel James, Sun Hill Brewery, Colwick Street (1835/40)

Christopher Sturtivant, Finkhill Street (1854)

James Thomas, Sun Hill (*Pigots Directory* 1841)

George Turner, Wellington Brewery, *Sir John Borlase Warren*, Derby Road, Sion Hill, Radford.

Brewer/maltster 1840-1860, also owned beerhouse, Kensington. (See also chapter on Shipstones).

Carrington Brewery

Established 1832 (see chapter on Shipstones).

Newark-on-Trent

The Town and Victoria Breweries are featured later. There were two renowned home-brew inns:-

Clinton Arms Brewery, Clinton Arms Inn, 38 Market Place

Thomas Walton 1841;

With Henry Walton, as Thomas Walton & Son 1861;

Ceased 1872.

CLINTON ARMS INN,
POSTING, COMMERCIAL, AND FAMILY HOTEL,
MARKET-PLACE, NEWARK-UPON-TRENT.

THOMAS WALTON,
SUCCESSOR TO MRS. LAWTON.

PRIVATE ROOMS FOR FAMILIES AND PARTIES.
WELL-AIRED BEDS.
Dinners provided at the shortest notice.
EVERY VARIETY OF CHOICE OLD WINES AND SPIRITS,
HOME BREWED ALE, LONDON PORTER, &c.
Commodious Commercial Room fronting the Market-place.
An Ordinary at Two o'Clock for Gentlemen attending the Fairs and Markets.
Post Horses, Chaises, Flies, and Mourning Coaches.
COACHES TO ALL PARTS OF THE KINGDOM.
EXTENSIVE STABLING & LOCK-UP COACH HOUSE.

Home-brewed ales, The Clinton Arms, 1842.

Newark Arms Brewery.

R. SHEPPARD

Begs to thank the Inhabitants of Newark and its vicinity, for the kind patronage they have bestowed upon him during the time he has been in the WHOLESALE BUSINESS; and assures them, his utmost endeavours shall be used to supply a good article at the smallest possible profit, and of the best quality.

R.S. has now in stock a quantity of CHOICE BREWINGS, in Casks of 6, 9, 12, & 18 Gallons, from 10d. to 1s.4d.

PRIME PORTER AND STOUT,

IN ANY SIZED CASKS, FROM 1s.2d. to 1s.6d.

SPLENDID BITTER ALE

AT 1s.4d. PER GALLON.

☞ R.S. will have great pleasure in promptly executing any Orders his country friends may favor him with,—carriage free: and also, any parties requiring first-rate Liquors of any quantity.

Sheppard advertisement of 1865, proclaiming Prime Porter and Stout and Splendid Bitter Ale.

Newark Arms Brewery, Newark Arms Inn, Appleton Gate
Henry Naile 1841;
Richard Smith 1855;
R. Sheppard 1861/65 (Richard Reckerby Sheppard listed at *The Robin Hood*, Lombard Street, in 1876 – may have been the same man).

Dominant Nottingham Brewers – Shipstones, Star Brewery, New Basford

James Shipstone founded Star Brewery in 1852 behind the *Horse & Groom* public house, Radford Road, in what was a small but growing suburb of Nottingham. Offices and stores at Stockwell Gate, Mansfield, followed.

Before 1876, his son James joined the business, trading as James Shipstone & Son. In 1884, another son, Thomas, joined to form James Shipstone & Sons, becoming a limited company in 1891.

An additional 150-quarter brewhouse was constructed in 1900, designed by William Bradford. Alfred Barnard, the celebrated beer writer, visited the brewery around 1891, described the whole site of red-brick buildings as covering upwards of 2 acres and commented on the 'lofty' brewhouse tower, some 70 feet high, climbing a steep

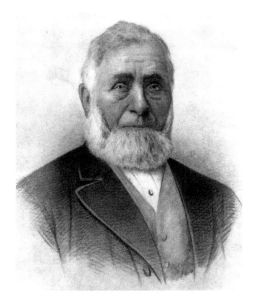

James Shipstone – founder.
(*House of Shipstone*, 1952)

staircase to get to the top. He remarked, 'Oh, those stairs, how they tired us!'. He was suitably refreshed later, sampling Shipstone's EO Ale – 'well flavoured with the hop and highly nutritious' – and XX – 'particularly bright and sparkling'. He saw the brewery cellars 'excavated out of solid rock'.

A succession of family members ran Shipstones. James Shipstone died in 1897, his son James becoming chairman and serving until his death in 1922. Brother Thomas succeeded, assisted by two nephews, James Henry and Ronald. Thomas, knighted for his service to Nottingham in working for and encouraging many charitable organizations, died in 1940.

Shipstones' beers were well regarded, with a Championship Gold Medal being awarded in 1906.

By 1978, Shipstones owned 250 pubs in Nottinghamshire, Leicestershire, Derbyshire and Lincolnshire but, in June, it was bought by Greenall Whitley & Co. Ltd of Warrington for £20 million. Greenalls quit brewing themselves in 1991, and the Star Brewery closed – but the lofty buildings still dominate New Basford.

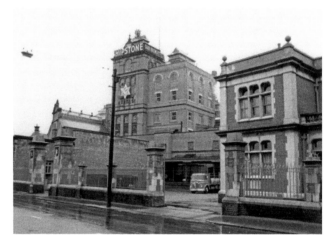

Star Brewery, New Basford. (Frank Baillie)

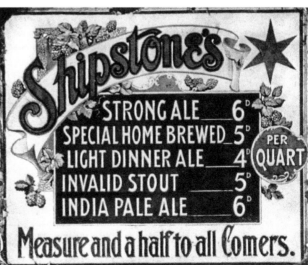

Advertisement listing Shipstones beers. (House of Shipstone 1952)

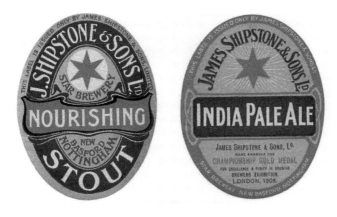

Early Shipstone labels.
(Author)

In 2013, Richard Nash, a Nottingham-born man, left AB-InBev after sixteen years' service to re-establish the Shipstone name. Shipstone's Bitter was relaunched in bottle, brewed by Colin Brown, who is an ex-Shipstones brewer and owner of the Belvoir Brewery, Leicestershire. Gold Star and Original followed.

Acquisitions

1898: Carrington Brewery, Jenner Street, Mansfield Road, Carrington

Founded in 1832, it traded as Beasley & Champion in 1840/41, with stores at Atkin's Yard, South Parade, Nottingham. From 1850 to 1855, Thomas Calvert Beasley was brewing but, in 1857, John Oldham Beasley was owner, with Thomas Noble Beasley taking control in 1862.

George M. Smith traded from 1864 to 1866; by 1871, R. W. Smith & Co. were owners. By 1872, Carrington Brewery Company Ltd was in operation, with Richard Henry Shaw as managing director and George Hickton as manager.

The building was demolished in 1938.

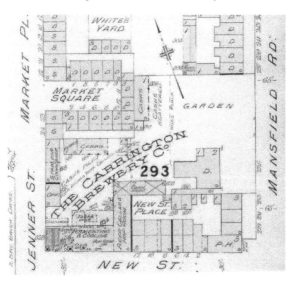

Goad Insurance Map extract, 1893.

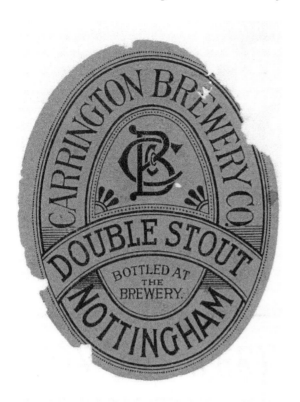

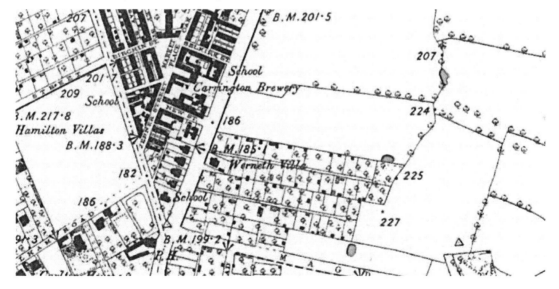

TELEPHONE No. 563.

ESTABLISHED 1832.

CARRINGTON BREWERY CO.

CARRINGTON.

FAMOUS

"ROBIN HOOD" ALES

SUPPLIED IN CASKS.

		Price per Gall.	54	36	18	12	9
MILD ALE - - -	X	1/-	54/-	36/-	18/-	12/-	9/-
Do. do. - -	XX	1/2	63/-	42/-	21/-	14/-	10/6
Do. do. - -	XXXX	1/4	72/-	48/-	24/-	16/-	12/-
STRONG ALE -	EO	1/6	81/-	54 -	27/-	18/-	13/6
INDIA PALE ALE -	PA	1/6	81/-	54/-	27/-	18/-	13/6
BITTER BEER - -	BB	1/2	63/-	42/-	21/-	14/-	10/6
DOUBLE STOUT - -	SS	1/3	67/6	45/-	22/6	15/-	11/3

DISCOUNT FOR CASH ON DELIVERY.

BOTTLED BEERS & STOUT.

ROBIN HOOD ALE. STRONG ALE.
INDIA PALE ALE. DOUBLE STOUT.

TOWN OFFICE :—

28, Upper Parliament Street,

NOTTINGHAM.

Above left: Double Stout label. (Author)

Above right: Advertisement, 1893, showing other products.

Below: Brewery location *c*. 1885.

The Cross Keys, Bulwell.
(Carrington Brewery)

1922: The Beeston Brewery, Ryelands Road, Beeston

This dates back to *c.* 1835, when it was operated by John Manning Needham. It later traded as Corbould & Faulkner, and a new brewery was built in 1880, designed by Wilson & Co. of Frome. Beeston Brewery Co. Ltd was registered in 1882, with an office at Carlton Chambers, Victoria Street.

Samuel Theodore Bunning was appointed manager of the brewery in 1883. Born in Cosby, Leicestershire, in 1846, he first worked as a clerk at Kibworth station and advanced to station master at Moseley, near Birmingham, becoming station master at Beeston in 1869.

In 1883, the company owned The Malt Shovel, Beeston, and The Shakespeare's Head and The Royal Oak at Leicester; later, they also controlled pubs in Nottingham, Derby, Wigston, Twyford, Syston, Mount Sorrel, Bramcote, Thurmaston, Loughborough and Lutterworth.

In October 1896, the brewery became the New Beeston Brewery Co. Ltd, with Samuel Theodore Bunning, George Wigley, James Inglis, and Joseph Albert Arnold as directors.

Bunning, living at Borrowash House, Borrowash, Spondon, was a wealthy man and benefactor; the Derbyshire Royal Infirmary received many gifts from him.

Nine-tenths of trade was with their own pubs. Maltings in Hanlip Street, Leicester, were also owned. The title of the business again changed in 1897 to the Beeston Brewery Co. Ltd.

By 1911, the company was experiencing poor financial results. At the annual general meeting, several Sheffield shareholders sought explanations. An investigation committee appointed to examine the company's finances made their report in May 1912, highlighting a general decline in sales, which was perhaps inevitable given the generally depressed trading conditions, fairly hostile licensing legislation and increased costs. It found the company had been originally 'over-capitalised' and criticised an agreement with Samuel Bunning requiring that his houses to be supplied at a discount, believing Bunning's position as chairman conflicted with his ownership of houses.

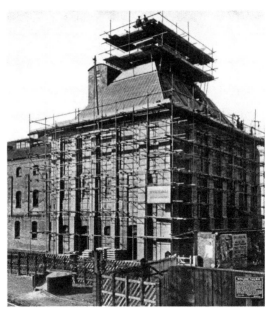

Above left: Samuel Theodore Bunning.

Above right: Beeston Brewery.

Interest in Beeston Brewery from other breweries began to appear. In July 1919, Mitchells & Butlers, Smethwick, enquired and were invited to make an offer, but nothing materialized.

Shipstones were interested; in May 1919, they agreed to purchase £70,000 in company debentures. By February 1920, negotiations with Shipstones were progressing; they showed particular interest in the licensed houses. Chairman James Shipstone viewed them personally.

The brewery was absorbed on 1 July 1922 and converted to maltings around 1925.

1926: Wheatsheaf Brewery, Radford (with thirteen pubs for £145,000)
George Hooley – born in Wollaton in 1841 – was a home brewer at the Wheatsheaf Inn, 72 Ilkeston Road/Mountford Street from *c*. 1876. He died in 1906, the business then operating as the Exors. of George Hooley until January 1911, when George Hooley Ltd was formed with a capital of £35,000.

Around 1915, brewing was transferred to larger premises at the corner of Grant and Highurst streets, where 'wheatsheaf' draught and bottled ales were produced.

1954: Midland Brewery, 119 Northgate, New Basford
Built in 1870 by Abraham Poynton, it traded as Abraham Poynton & Company by 1876. Poynton apparently carried on the business on his own until 1880; in 1881, it was trading as Midland Brewery Company.

Benjamin Robinson – born in Ilkeston in around 1843 – was owner between 1885 and 1887 and publican at the Barleycorn Inn, 43 Raleigh Street. The next occupiers

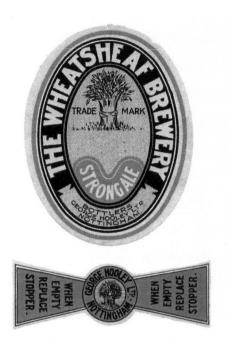

Above left: Hooley pub sign.

Above right: Strong Ale label. Home Brewed, Nut Brown Ale and Special Luncheon Ale were also bottled. (Author)

Below: Wheatsheaf Brewery, later Midlands Counties Ice Cream factory. (Reg Baker)

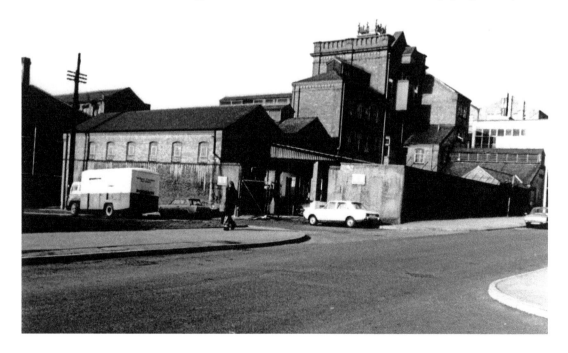

were Malden & Dell but the premises were named Lion Brewery, rather than Midland. *The Brewing Trade Review* recorded Malden & Dell's acquisition by Lawrence Levy in 1887, trading as Lawrence Levy & Co., but by *c*. 1890, they had ceased.

The premises were unoccupied in 1894–1899 and probably were until 1902, when bought by Hiram R. Fletcher, who went bankrupt three months later.

By 1904, the brewery was occupied by Thomas Losco Bradley; like Benjamin Robinson, he was victualler at The Barleycorn. Born on 13 December 1868 in Radford, his father, Thomas Bradley, ran The Cricketers beerhouse, 154 Alfreton Road, from before 1881, being listed at an unnamed beerhouse in Ilkeston Road in 1876. The son of James Bradley, a coal dealer in London Road, he operated that business following his father's death, while living with his mother, Sarah, at 32 Castle Terrace.

The 1881 census listed Thomas Bradley Senior and son, Thomas, aged twelve, living at The Cricketers. In May 1897, young Thomas married Alice Ellen Gregory at St Barnabas' Cathedral, Nottingham; they lived at Munden House, 9 Second Avenue, Sherwood Rise, but the marriage ended in divorce thirty years later. On 28 March 1929, Thomas died at Holly Lodge, Oxton, aged sixty-one. His son, also Thomas Losco, born in March 1898, continued the business.

Bradley chose the lion emblem as his trademark, reflecting the brewery's previous name. This was depicted as a red lion, although the Rufford Ale label shows a blue lion.

Losco Bradley beers won an award in 1905, and also in 1928, when the brewery became T. Losco Bradley Ltd. In 1930 the name 'Bradley's Brilliant' was introduced, winning first prize at the Brewers Exhibition, 1932. Sales increased by 50 per cent afterwards. Bottling was carried out by Hart & Company of Bloomsgrove Street.

 The brewery owned over forty pubs including The Sir John Borlase Warren, Canning Circus.

There were large cellars on two levels underneath the brewery cut out of the rock. A lift was used to haul casks up to the yard for loading and delivery.

Thomas Losco Bradley Jnr lived at Elsing Hall, Norfolk, until his death in 1982. He was married four times. The brewery was demolished for housing in 1964.

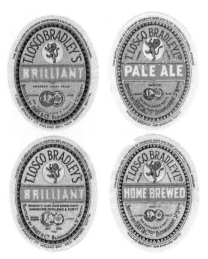

Losco Bradley labels – the second 'Brilliant' followed another award in 1932 (author). Strong Ale, Luncheon Ale, Draught Ale and Coronation Ale 1937 were also bottled.

Dominant Nottingham Brewers – Home Brewery, Mansfield Road, Daybrook

The Robinson family were farmers at Home Farm in the 1850s, with John Robinson operating the family's malting business in Arnold. In 1875, he paid £7,000 for land in Mansfield Road and built a brewery and maltings named after the farm – he traded as John Robinson from 1878 (the brewery centenary was celebrated in 1978). Offices and stores were established at 1/3 Upper Parliament Street, Nottingham. Initially, the brewery was producing fifty barrels a week. Robinson purchased local public houses.

In 1880, construction started on a large, steam-powered brewery that would produce a range of beers, including Family Pale Ale, Dinner Ale, Prime Invalid Stout, and a non-alcoholic Empire Stout (1s for a dozen bottles). When John Robinson's son, John Sandford Robinson, joined the business in 1890, a very strong commemorative ale was brewed, known as 'Johnny Robinson's Strike-me-Dead'. Ironically, the son died in 1898.

Smith's Arms, Hyson Green.

In 1890, John Robinson's Brewery Co. Ltd was registered with a capital of £300,000; it was followed soon after by the Home Brewery Co. Ltd, with £400,000 capital. The company controlled sixty-one pubs – considerable progress in just over twelve years. Over the next eight years, a further eighty-seven houses were acquired.

John Robinson was very active in local affairs, being sheriff of Nottingham, a county council alderman, a JP, and high sheriff of Nottinghamshire. He had, by 1912, virtually retired from the business; the managing director, John Thomas Farr, guided the firm through the restrictive period of the First World War. His nephew, Captain John Farr – who had joined the company in 1919 – succeeded him and became chairman when John Robinson died in 1929.

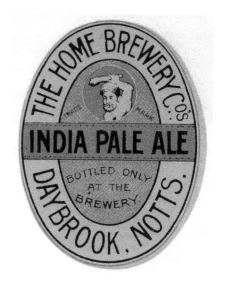

Right: Early label. (Author)

Below: Home Brewery. (Frank Baillie)

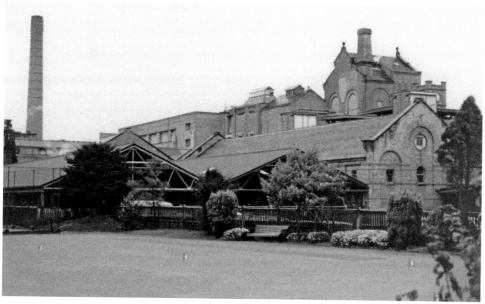

The rapid progress in pub acquisitions continued: fifty were bought in just five years between 1920 and 1924, with another thirty-one added by 1927. A new soft drinks plant was added in 1925, when beer production had increased to 2,500 barrels a week, with a further jump to 4,620 in 1926 when additional fermenters were installed.

In the late 1930s, the construction of a significant office building on Mansfield Road – designed by Nottingham architect Cecil Howitt – commenced. Although completed by the end of 1939 (apart from the tower), it was not fully occupied by the brewery, as it was requisitioned for a clothing factory.

In 1952 the office tower was added and there were major extensions and improvements to brewing capacity. Twenty new pubs were built in the decade up to 1957, and another twenty replaced closed properties. From 1963 to 1973, a further fifty-four houses opened and free trade business increased by 350 per cent; by the mid-1980s, 400 outlets were supplied.

A new bottling hall was erected in 1968 and a new brewhouse was completed in 1974, offering a capacity of 3,600 barrels a day. The Apollo bottling hall was rebuilt in 1975 and a new power house finished in 1976.

Since the inception of the company, labels and other advertising matter had the trademark of Hercules displaying a muscular arm, which was registered in 1926. In 1971, a Robin Hood trademark replaced Hercules. Another masculine figure, illustrated on the company's strong ale label, was Bendigo.

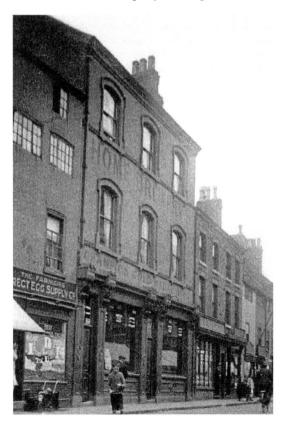

Crown & Anchor, Nottingham.

The Bendigo Story

William Abednego Thompson was born in 1811 in New Yard, Sneinton (now Trinity Walk), the youngest both of triplets (his brothers were named Shadrach and Meshach after the young men in the Book of Daniel) and of the family – his parents had eighteen other children! He became a prize fighter in 1832 and subsequently champion of the ring, winning all fourteen fights, with more than one lasting over ninety rounds. When he started fighting, his middle name was shortened, becoming 'Bendigo'.

On retirement in 1850, Thompson became a heavy drinker and broke the law, being imprisoned twenty-eight times for drunk and disorderly behaviour. A turning point in his life followed a sermon preached by Richard Weaver, a former collier. Thompson too became a preacher. Remarkably, when he was sixty, he rescued three people from drowning in the River Trent. He was a powerful man. Accepting a wager, he threw a brick over the river for a distance of 70 yards, using his left hand; on another occasion, he threw a cricket ball 117 yards. He died in 1880 at Beeston.

Bendigo had a city named after him in Victoria, Australia. His trophies were exhibited for several years at The Forest Tavern, Alfreton Road, Nottingham. A century after his birth, Sir Arthur Conan Doyle paid tribute to Bendigo in verse and shortened his name still further – to 'Bendy'. In 1957, Home Brewery rebuilt the Old Wrestlers at Sneinton, renaming it The Bendigo, complete with statue of the great man. They also introduced a special strong ale.

In 1978, Home celebrated its centenary. Plans were announced for a new brewery with a weekly capacity of 12,500 barrels – and the potential for 1 million barrels a year. This modernisation was completed in 1986.

In that year, Home was bought by Scottish & Newcastle Breweries for £120 million with 480 pubs – mainly within 50 miles of Nottingham city centre but extending to Derbyshire, Huntingdonshire, Leicestershire, Lincolnshire, Northamptonshire, Staffordshire, Yorkshire and Warwickshire. Yet over £5 million was spent over the next four years on new equipment, brewhouse automation and improvements to warehousing. A major repackaging and relaunch for Home beers took place in 1989/90, but they competed with Scottish & Newcastle products.

Rebuilt Bendigo,
Sneinton.

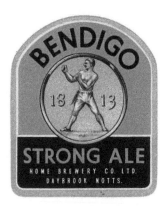

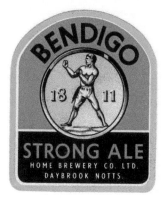

Bendigo – the first label got the date wrong! (Author)

In May 1996, brewing ceased at Daybrook; production of the Home Ales range was transferred to Mansfield Brewery. Bottling of Scottish & Newcastle beers continued to September 1996, when the site was closed, causing some 1,000 employees to lose their jobs.

The brewery buildings have been demolished and a supermarket erected on the site, with the road named after the founder. The only part of the site left is the former offices, now a listed building – they were purchased by Nottinghamshire County Council, and have been used as their offices since 1999. The tower still has part of the old lettering on it ('Home of the Best') but a County Council logo replaced the word 'ales'. In the space of a few years, the remarkable progress and achievements of this major brewery have been virtually obliterated.

However, the name 'Home Ales' was reintroduced in May 2015. Nick Whitehurst now brews Robin Hood Pale Ale at Oldershaws Brewery, near Grantham, having bought back the licence.

Acquisitions
1914: Hutchinson's Prince of Wales Brewery, Old Basford
The business, situated in Church Street/Alpine Street, was bought for £177,000; this added eighty-nine more licensed houses to the Home estate.

The brewery, established before 1850, traded as Samuel Robinson & Co. with Samuel Robinson Church Street; Lincoln Street; and Thurland Street, Old Basford

listed between 1854 and 1858. Robert Bidgood then ran the brewery around 1860, and Stephen Averill in 1862.

Henry Hutchinson had bought the business by 1869, trading as Henry Hutchinson in 1874; it became William Henry Hutchinson (born Bulwell, 1840) by 1876. The concern became W. H. Hutchinson & Sons Ltd in June 1894.

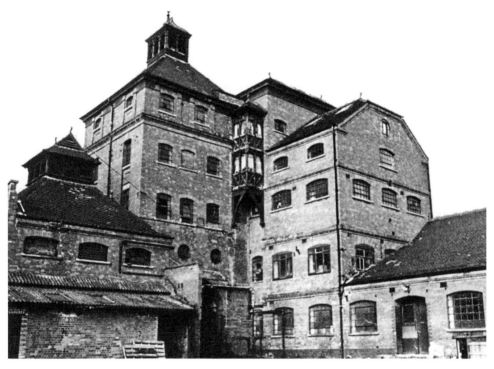

Above: Former Prince of Wales Brewery, Old Basford.

Right: Hutchinson's bottled beers, with Prince of Wales feathers trademark. (Author)

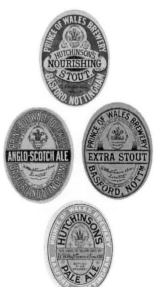

The brewery building – originally erected in 1881, but then rebuilt in 1891 to the designs of William Bradford – still stands (a Grade II listed building) and is used by Murphys, suppliers to the brewery trade.

1919/20: George Green & Sons, maltsters/owners of eighteen beerhouses
This included three home breweries – Royal Children, Newcastle Arms, and Sir Isaac Newton (below).

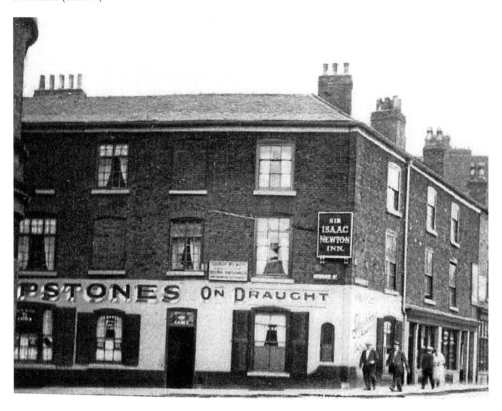

Dominant Nottingham Brewers – Nottingham Brewery Ltd

The large brewery at 52–56 Mansfield Road, founded by James Long in 1847, was known as the St Mary's Brewery. It traded as Long & Company from before 1854 to 1869.

Long sold the business in 1875; the owners were Mitchell and Rodwell in 1877, trading as the Nottingham Brewery Company. In 1879, Edward Wheeler Field bought the brewery; under his management, trade increased twenty-fold. In 1882, he registered the trademark 'Rock Ales', showing the brewery's extensive red sandstone rock cellars

LONG AND Co.,

MALTSTERS,

ALE & PORTER BREWERS,

ST. MARY'S BREWERY,

MANSFIELD ROAD NOTTINGHAM.

N.B. FAMILIES SUPPLIED WITH SMALL CASKS.

Advert, 1862.

The brewery dominating Mansfield Road.

where his celebrated ales were matured in cask. In 1885, the words 'Nottingham Rock Ales' were also registered. The business became Nottingham Brewery Ltd in 1887.

William Bradford, the renowned brewery architect, was commissioned to build a sixty-quarter new brewery. This was completed in 1889 with ornamental iron gates at the brewery entrance and bronze panels depicting, in brass, Gambrinus sitting astride a beer barrel, holding a tankard of beer. The five-storey brewhouse had Bulwell-pressed bricks and Mansfield stone dressings, with a Broseley-tiled roof, cupola, lantern, ornamental ironwork and flagpole. The whole building dominated Mansfield Road.

Soon after completion, Alfred Barnard toured the brewery with head brewer, Thomas Essex Neal. Barnard commented on the cellars, which covered 2,370 square yards (around half an acre):

> There are very extensive rock cellars, two tiers deep, extending over the whole area of the brewery premises, which are particularly adapted for storing beer, the temperature scarcely varying all the year round (53 degrees).

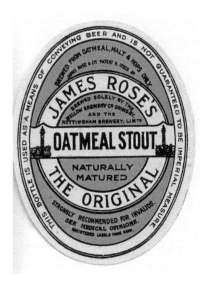

Roses Stout label. (Author)

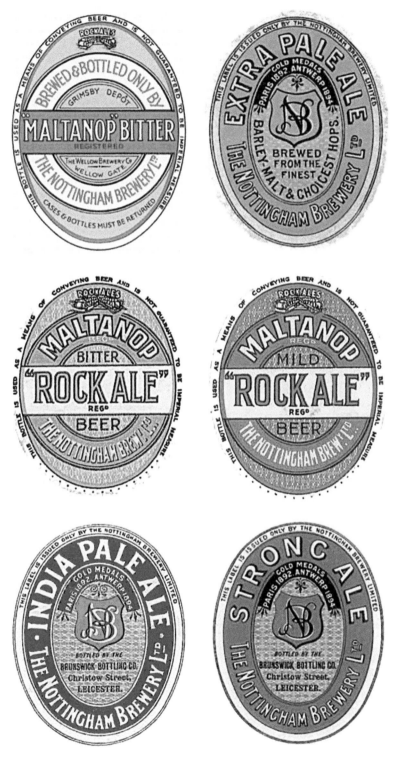

Nottingham Brewery bottled beers. (Author)

Barnard noted the thirteen different varieties of ales and stouts, tasting BB and XB bitter beer and proclaiming, 'both are deserving of praise, especially the latter, a delicate, sparkling ale, with a good hop flavour and very nutritious'.

The brewery controlled, around this time, 180 pubs and had a thriving family trade, with agencies at Leicester, Lincoln and elsewhere. In 1892 and 1894, at Paris and Antwerp, the company won gold medals for the excellence of its beer. A newspaper extolled the fame of the brewery, writing that 'Rock Ales are celebrated throughout Nottingham and surrounding country for their excellent quality and fine flavour, the delicacy of which can be scarcely surpassed'.

Acquisition
1900: The Wellow Brewery Co., Grimsby
Wellow owned nineteen pubs and the subsidiary, James Rose & Co. of Nettleton. Wellow had been run by Edward Anton Lewis before 1894, and then by Lewis & Barker. James Rose had patented, in 1890, stout or porter using oatmeal, crushed oats or oaten made from malted oats. Nottingham Brewery became the owners of the patent and were concerned about possible patent infringement. Their solicitors, Maples & McRaith, gave warning in a newspaper notice of 1901 that proceedings would be taken against any such infringement.

In December 1924, the firm registered the term 'Maltanop' on a pale ale label, claiming use from 1904. This term was applied to all the bottled beers produced by Nottingham Brewery and the Wellow Brewery.

In 1944, Tennant Bros Ltd of Sheffield bought Nottingham Brewery with its 150 pubs. Bottling ceased at Nottingham as well as brewing at the Wellow Brewery, in 1948. Brewing at Nottingham continued to 1952. The dark mild, Rock Ale, was then brewed at Sheffield for several years.

The premises were sold by Tennants to Whitbread, and Mackeson Stout advertised on the brewery tower. In 1960, the site was sold to developers and the brewery demolished. The Rose of England, the brewery tap, survives.

Dominant Kimberley and Mansfield Brewers

Hardy & Hansons

In 1832, Samuel Robinson rented an old bakehouse in Cuckold Alley, Kimberley, from Thomas Godber and converted it into a brewery. Like other Nottingham breweries, it contained cellars constructed from solid rock. Following a number of partnerships, Robinson was, by 1854, trading as Sheppard & Robinson, then Robinson & Sheppard. In 1857 they sold out to the Heanor brothers William and Thomas Hardy, who had traded since 1850 as wholesale beer merchants. The Hardys already bought beer from three breweries but customer demand called for more.

William Hardy did the brewing and managed the brewery; Thomas sold the beer throughout Nottinghamshire, and managed the finances. In four years, the business prospered and capital was accumulated to build a bigger brewery.

On 18 May 1861, the Hardys bought around an acre of land in Spring Flatt, Brewery Street, from Thomas Godber for £301 and 5s, and built a ten-quarter red brick brewery

Thomas Hardy. (Kimberley Ale)

on the opposite side of the street to Stephen Hanson's brewery. It was designed by Robert Grace of Burton-on-Trent with maltings, bottling and cask filling cellars, offices and stables. Once completed, they vacated the former Robinson's Brewery. Water for brewing came from the nearby Alley Spring – it was filtered through rock, imparting excellent mineral properties.

By 1868, the Hardys decided to supplement their water supply and bought a field adjoining the Holly Well watercourse. Owner Earl Cowper leased in 1873 the well's water supply to both the Hardys and Stephen Hanson. Around this time, draught beers were XX mild, Stout, XXX mild, XXXX, and Pale Ale.

The brewery plant was enlarged in 1870 and new buildings were added, with new maltings being commissioned in 1875. On 7 May the partnership between the Hardy brothers was dissolved; William, at age forty-six, was ill and wished to retire, selling Thomas his half share in the business for £2,500.

In 1882, Robert Grace designed a new thirty-five-quarter brewery with buildings covering 4 acres. Eben and Frederick Hardy had joined the business. Eben invited Alfred Barnard to sample the firm's beers when he toured the brewery in 1888. Draught Special Dinner Ale and XXXXX Strong Ale, as well as bottled India Pale Ale and Double Stout, were enjoyed.

Thomas Hardy had commenced the purchase of pubs relatively early, buying in 1868 the Cricket Players' Arms near the brewery and, in the 1870s, a home-brew inn, The Wellington at Eastwood, with its adjoining brewhouse, stables and coach house. By 1897, they owned ninety-seven pubs and twenty-five off licences.

On 6 May 1897, Hardy's Kimberley Brewery Ltd was formed to acquire the business for £450,000; the last year's profit was nearly £19,000. Thomas did not see the success of his new company, dying suddenly on 27 June 1897, aged sixty-four. Eben and Frederick Hardy then ran the brewery until Frederick's death in March 1917. Charles Hardy, the youngest brother, joined the board.

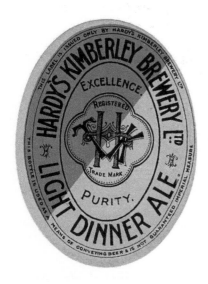

Early Hardy's label. THK – Thomas Hardy, Kimberley. (Author)

Sales declined in the late 1920s and talks were undertaken with Hansons Ltd, of the Kimberley Brewery opposite, with a view to a merger.

Hanson's Brewery's story began on 13 July 1846, when Stephen Hanson, yeoman and former farm manager, bought for £316 land in Brewery Street at an auction at The Stag Inn, Kimberley. It measured 1,606 square yards, with six cottage tenements. After paying compensation to the tenants, Hanson took a partner, John Tomlinson, local beerhouse keeper and maltster, trading as Tomlinson & Hanson, and commissioned an architect to build a red-brick and stone brewery, which was completed in 1847. Hanson began to brew strong ale in twenty-barrel quantities, using Alley Spring water.

In 1856, Stephen's second son, Robert Goodall Hanson, aged thirteen, joined the brewery. Five years later, his father died and Mary Hanson, Stephen's widow, continued the business, with Robert's help as brewery manager, rather than sell it. She traded as Mrs Mary Hanson & Son. On 22 September 1869, when his mother was sixty-eight, Robert Hanson became the owner. In 1872, he erected a new four-storey brewhouse, with fermenting house, loading-out rooms and malt and hop stores, and stables – adding another fermenting room soon after.

Alfred Barnard visited in 1888 and praised Hanson's beers, sampling the Guinea Ale and IPA, which were described as equal to any Burton ale. Later, in his *Noted Breweries of Great Britain*, he referred to Hansons' awards at the Brewers Exhibition, 1889, for XXX (a remarkable beer) and 1/6d Bitter (very fine).

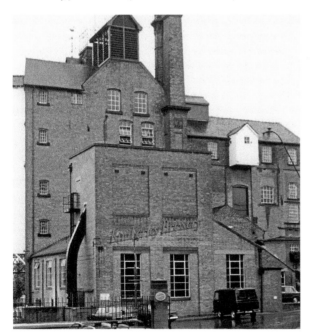

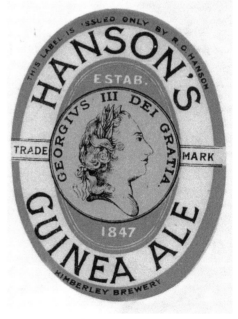

Above left: Hardy's Brewery. (Frank Baillie)

Above right: Hanson registered a George III gold guinea as his trademark 1866, shown in this pre-1897 label. (Author)

Robert Hanson's two sons, William Banner and Robert Adolphus, joined the business, with William becoming brewery manager in 1889 and Robert assisting. Trade had increased substantially. In 1895, a new six-storey brewhouse tower was completed, designed by William Bradford, with other extensions and a private railway siding. Four very large gilded reproductions of the George III golden guinea topped the tower.

Hanson's Ltd was formed in 1897, with a nominal share capital of £200,000, eighty-four pubs and sixty-six off licences, and other properties and total assets of over £223,000.

Robert fell ill early in 1903 and in March, after returning to work after three months, had a heart attack and died. William Hanson became chairman and managing director, with his brother Robert becoming a director and younger brother, Henry, joining the board.

Apart from Guinea Ale, early bottled beer included India Pale Ale, Brown Stout, Strong Ale and Special Mild Ale. The brewery won, in 1929, the Brewers' Exhibition and *Brewing Trade Review*'s prestigious Challenge Cup for the best bottled beer from 198 entries, also winning a first prize and silver medal. *BTR*'s editor visited to praise the brewing plant and system, the water, and the cellars and cellarage system. Similar success in bottled beer came in 1931.

William Hanson died on 14 May 1930 after talks had been held with Hardy's Kimberley Brewery with a view to amalgamating. Hardy Hansons Ltd was formed on 30 October 1930. In 1932, brewing was confined to one site; Hansons' brewery last brewed on 22 December and became a bottling store.

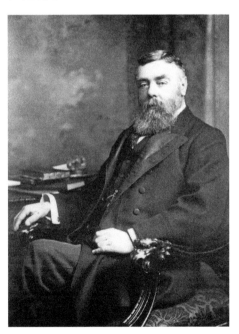 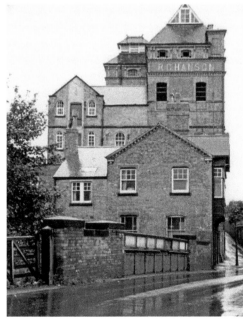

Above left: Robert Goodall Hanson, the founder's younger son. (Kimberley Ale)

Above right: Hanson's Brewery. (Frank Baillie)

Beer on draught and in bottle still had the Hansons' label, but the product was identical (e.g., Hardy's Nut Brown Ale was also Hansons' Special Mild Ale).

The separate trading identities of Hardy's Kimberley Brewery and Hansons Ltd were integrated in 1972 and Hardy & Hansons Ltd was formed. The old Hansons Brewery was demolished in 1973.

A new bottling plant came in November 1951 and success followed in 1952 at the Brewers Exhibition, winning for best draught beer. Other awards followed in 1972, when the draught beers were Mild, PMA and Best Bitter, with Hardy's Nut Brown, Hansons' Special Mild, Starbright IPA, Old Kim (introduced November 1949), Blackamoor Stout (introduced June 1950) and Guinea Gold Ale (introduced 1956). Discontinued during the war were Hansons' Strong Ale, Hardy's Home Brewed Strong Ale XX Mild. Hardy's Dark Amber stopped in 1957. Shares of the company were floated on the stock exchange in 1962.

The business was bought by Greene King & Sons Ltd in 2006 for £275 million with 250 pubs and brewing ceased.

Mansfield Brewery, Littleworth

The brewery, started in 1855 as a venture likely to succeed in an important malting centre, was operated by a succession of partnerships for seventy years. The founders were William Baily, Samuel Hage (Ollerton farmer and maltster) and John Watson (leaving his brewery at Sheffield), trading as William Baily & Company.

On 24 April 1856, John Watson relinquished his interest for £450; the brewery then traded as Baily & Hage. Addison Titley joined on 15 November 1873, paying £2,000 (a sixth share). The firm was Hage & Titley in 1876, owning nineteen pubs. In 1878, Titley, William Edward Baily and his uncle John Baily formed Titley, Baily & Baily. Titley retired in 1885, leaving W. E. Baily, H. S. Shacklock, William Jackson Chadburn and

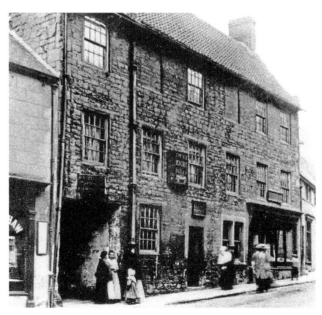

Eight Bells, Mansfield – bought in 1895 for £2,910.

James Handley Hopewell as partners. Chadburn became the dominant partner and, by 1901, when he had been in control for sixteen years, sixty-six pubs, hotels, and beerhouses were owned. In that year, E. A. Titley and Walter Titley joined the partnership.

A new brewery was built in 1907, enabling the firm to increase barrelage from 17,000 to 20,000 per annum. Francis Ludlow and Claude Chadburn became partners in 1910. S. C. Deakin was brewer after the First World War, considerably improving the plant; he had a reputation for quality and remained a trusted friend and adviser to the firm until his death in 1959. His son, Edward Deakin, joined in 1928 and, on his father's retirement in 1947, succeeded him as head brewer, finally retiring in 1971. In the 1990s, as a commemoration, bottled beers produced by Mansfield Brewery bore the Deakin name.

One of the brewery's most renowned products was 'Golden Drop'. Produced from the early 1900s, it continued for many years. Other bottled beers were Home Brewed Ale, Strong Ale, Mild Ale, Pale Ale, No. 1 Bitter Ale, Nut Brown, and Light Ale. From the 1980s onwards, there was Best Bitter, Red Admiral, Royal Stag, Wild Boar and White Rabbit.

The company traded as Mansfield Brewery Company to February 1925 when incorporated, becoming Mansfield Brewery plc in 1982.

By 1977, 181 pubs were owned, mainly in the counties of Derbyshire and Nottinghamshire (thirty-three in Mansfield, ten in Chesterfield) with some in Yorkshire and Lincolnshire.

In 1975, Marksman Lager was introduced. Soft drinks manufacture ceased in 1976. A new line in PET bottles was started, supplying to supermarkets and other outlets under their own label.

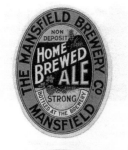

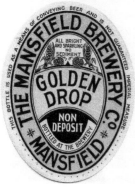

Early Mansfield labels. Golden Drop (gold foil label) was issued for HRH Princess Anne's wedding, 1973. (Author)

Acquisitions

1934: Chesterfield Brewery Co. Ltd, Brimington Road, Chesterfield
(with nearly 100 houses – from Sheffield to Alfreton)

Founded in 1853, it was formed into a limited company in 1898, acquiring TP Wood & Co., wine and spirit bottlers, in 1911. The brewery closed and later became a sweet factory.

1955: Hornbys – local soft drinks manufacturer
(with a bottling and wholesaling business and six pubs)

1985: North Country Breweries Ltd, Anchor Brewery, Silvester Street, Hull
(for £42 million, with 200 properties extending the tied estate to East Yorkshire)

Formerly the Hull Brewery Co. Ltd, founded in 1765 in Dagger Lane, Hull, the company traded as Gleadow, Dibb & Company before moving to Silvester Street in 1868 when it became the Hull Brewery Company in 1888. The name changed after purchase by Northern Dairies on 29 March 1974. Riding Mild and Riding Bitter were introduced for the former North Country outlets.

Over the years, improvements and changes were made to the Mansfield brewing plant, including new bottling stores and, in 1984, a new brewhouse commemorated by a special bottled beer.

In 2000, Mansfield Brewery was purchased by Wolverhampton & Dudley Breweries (Banks') with 500 pubs; inevitably, with Marstons of Burton also falling to Banks', there was surplus capacity. Production of Old Baily, the brewery's strong ale, stopped in April 2000. Brewing ceased at Mansfield at the end of 2001.

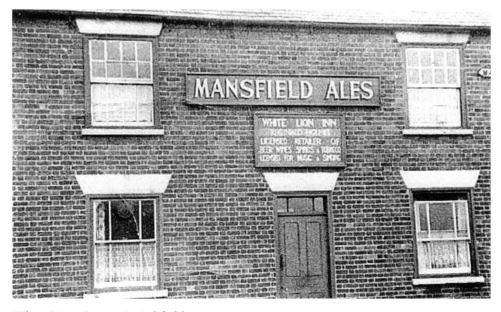

White Lion, Sutton-in-Ashfield.

Dominant Newark and Worksop Brewers

James Hole & Co. Ltd, Castle Brewery, Albert Street

In March 1879, John Smith Caparn of the Robin Hood Brewery and Douglas Hankey bought for £800 land in Albert Street, Newark, which was occupied by an old workhouse, hospital and prison and starch factory. They then built the Castle Brewery. John Goodwin was head brewer and partner, with Caparn, Hankey and Herbert Maynard Hatfield, the firm trading as Caparn Hankey & Company. In 1881, substantial offices in the French Renaissance style were erected, costing around £10,000.

By the following year, John Goodwin had left to run the Balderton Gate Brewery; John Smith Caparn was a sleeping partner. Expenditure on the offices resulted in bankruptcy. In 1885, the Castle Brewery was bought by James Hole (who was senior partner in James Hole & Co., maltsters of Northgate) and his first cousin, Samuel Kercheval Marsland.

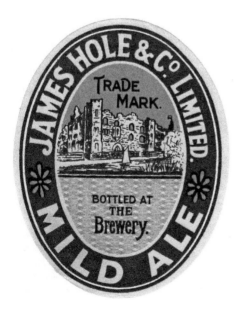

Early label, with Newark Castle registered trademark. (Author)

CASTLE BREWERY.

NEWARK-ON-TRENT.

JAMES HOLE & CO.

(LATE CAPARN, HANKEY, & CO.),

BREWERS OF

ALES AND STOUT.

And the Celebrated "A.K." LUNCHEON ALE.

In 9, 18, 36, and 54 Gallon Casks. Delivered Free.

Above: Hole's advert.

Right: James Hole was active in town affairs, serving as mayor in 1888 and 1898.

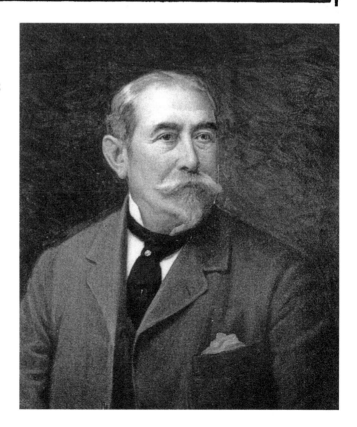

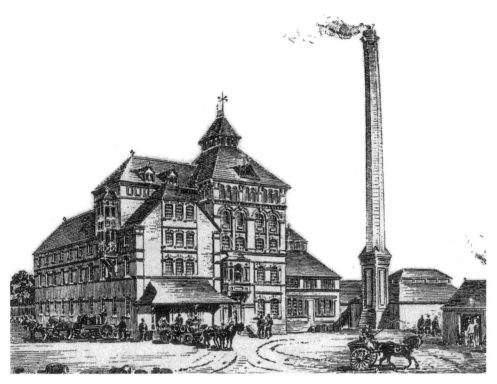

New brewery, 1890, designed by William Bradford. (*Brewers Journal*)

The brewery took the name of the maltsters; both activities were conducted until September 1934, when the maltings were leased to Bairds. In 1890, the business was incorporated, with Arthur Gilstrap Soames joining the firm as a third partner.

Acquisitions
c. 1900: Fox Brewery, Fox Road, Whitwell
(Pubs – Jug and Glass, Whitwell, Royal Oak, Bakestone Moor and off licence – Fox House)

1927: Market Rasen Brewery
(thirty-three pubs)

1935: Lowe Son & Cobbold, St Michaels Brewery, Broad Street, Stamford

Hole's business was bought by Courage Barclay & Simonds in 1967 with 240 pubs and off licences for £6 million. Courage acquired John Smith's Tadcaster Brewery in 1970; Hole's came under Smith's control in 1971, together with Warwicks' & Richardsons' pubs, which were bought by Smiths in 1962. Brewing ceased at the Castle Brewery in November 1982; the offices closed in May 1991. The buildings have been converted for residential use.

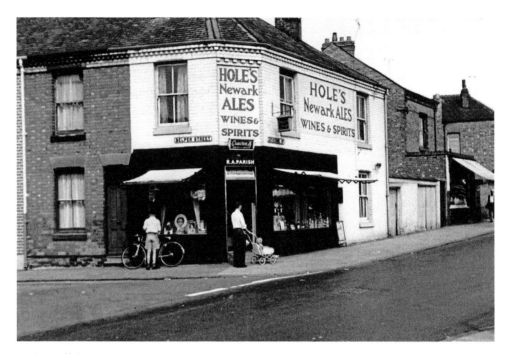

Hole's off-licence, Lincoln.

Warwicks & Richardsons, Northgate Brewery, Northgate
Town Wharf Brewery, Northgate

This, the first commercial brewery in Newark, was founded by Samuel Sketchley of Burton-on-Trent in around 1766, after leasing premises from the Duke of Newcastle. Joining with banker William Handley in the 1770s, he established a cotton mill in Newark – the partnership extended to the brewery (with Jessop and Marshall) and a business of raff (foreign timber) merchants.

A considerable export trade was established in Northern Europe and Russia. After the Russian government levied heavy duties on imported British beer, the brewery concentrated on the home trade. The *Universal British Directory,* 1791, listed John Reynoldson but, in 1798, Handley died, while Sketchley retired in 1800. Other Handleys then joined – Benjamin and William Farnsworth in 1801. In 1808, John Reynoldson left. The Handleys had control, with William F. and John being listed between 1828 and 1835. *Pigot's Directory,* 1841, showed John Handley as proprietor.

Richard Warwick, brewery manager, bought the brewery in 1856, taking his eldest son, William Deeping Warwick, into partnership, trading as Richard Warwick & Son. Around 1872, Richard Huskinson Warwick, second son, joined, the firm becoming Richard Warwick & Sons. Operations moved to their new Northgate Brewery on land that been assembled since 1863, with links to two local railway lines – the first brew being on 14 September 1872.

The Town Wharf Brewery closed. Richard Warwick died in 1877 and William Deeping Warwick became senior partner.

Town Wharf Brewery.

In 1883, the firm registered its trademark on labels for bottled beers, depicting a Napoleon III silver medal, won at an International Brewers Exhibition in Dijon in 1866.

Richard Warwick & Sons Ltd was formed on 1 July 1888; in 1890, it merged with Richardson Earp & Slater's Trent Brewery Company to form Warwicks & Richardsons Ltd.

The Trent (formerly Victoria) Brewery, Millgate

A brewery on the site, extending to the banks of the River Trent, had existed from *c.* 1802, and had successive owners. By 1840, William Bowler was brewing Porter and Harvest Ale in the Victoria Brewery. By 1844, Howe, Truswell & Berry (probably with Sheffield connections) were brewing (Howe & Company 1850). John Madin & Company traded by 1853, becoming Madin & Webster by 1855. Richardson, Earp and Slater became owners in 1857.

Joseph Richardson, maltster, was senior figure in the brewery with Thomas Earp, aged thirty in 1861, 'a partner in brewery employing twenty-one men'. He became mayor of Newark three times and Liberal MP for Newark in 1874, retiring from the firm in 1885.

William Slater, the third partner, had operated a posting business at the Clinton Arms Inn in Newark Market Place, later moving to the Saracens Head next door, where he brewed in 1855.

Joseph and Charles Richardson were sole owners by 1880, with James B. Richardson brewer in 1881.

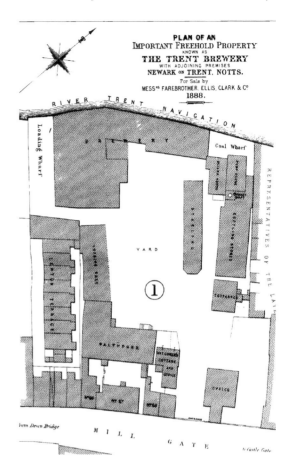

The Trent Brewery had bottling stores, stables, cooperage, offices, malthouse, loading shed and coal wharf.

Acquisitions

1888: Royal Oak Brewery, 34 Stodman Street, Newark

(pub bought by Richardson's Trent Brewery for £2,450)

Dating back to 1650, it had a small brewhouse, which ceased in 1881. It was run by William Taylor from 1832, after moving from the Spread Eagle, Middlegate, until his retirement around 1843. It was then continued by his maltster son Samuel Taylor until his death in 1865, when it was then operated by his widow Elizabeth and son Samuel, trading as E. Taylor & Son. Samuel became proprietor in 1878.

In 1889, the Richardsons sold the Trent Brewery Company to Richard Warwick & Sons' Northgate Brewery for £55,042 to form Warwicks & Richardsons Ltd, with all brewing at Northgate Brewery. The Trent Brewery trademark – depicting the Newark coat of arms – was adopted by the new firm.

The former Trent Brewery buildings were used by a firm of wind-pump manufacturers but were demolished in 1952.

At the Northgate Brewery, new offices were built, designed by William Bliss Sanders. By then, the brewery was producing around 100,000 barrels a year and employing 133 persons. The company was reconstructed in 1897, owning 201 pubs.

SAMUEL TAYLOR,

WHOLESALE AND RETAIL BREWER,

WINE AND SPIRIT MERCHANT,

Bass & Co.'s Burton Ales in Casks or Bottles. Guinness, Son & Co.'s Dublin Stout.

CIGARS OF THE FINEST BRANDS.

SPLENDID HOME BREWED ALES IN FINE CONDITION,

In casks of 6, 9, 12, 18 or 36 gallons, at 1s., 1s. 2d., 1s. 4d. & 1s. 6d. per gallon.

FAMILIES SUPPLIED WITH

Single Bottles at Wholesale Prices.

ROYAL OAK BREWERY, STODMAN ST.,
NEWARK-UPON-TRENT.

Samuel Taylor advertisement, 1865.

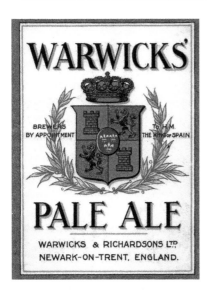

Label showing King of Spain appointment. (Author)

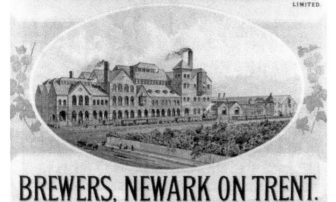

Early brewery poster.

1892: Newark and Sheffield Breweries, Oliver Cromwell Brewery, 71 Barnby Gate, Newark

James Hooton established the brewery at the Cromwell Tavern in 1867, but the 1861 census showed him as a common brewer, following his father, William. On 3 March 1875, James died at the brewery, which then appears to have passed to the Smith family, trading as J. W. Smith & Son with manager William Moss, former printer and furniture auctioneer, and publisher of the *Newark Herald*. Moss acquired the brewery in 1884 on J. W. Smith's death, forming the Cromwell Brewery Company.

After 1885, the brewery passed to Thomas William Alexander, trading as Howe & Alexander.

Alexander sold the brewery around 1888 to Lionel Charles Bastow, trading as L. C. Bastow & Company. Bastow, however, was declared bankrupt, with the business later passing to Jessop and Hopewell of the nearby Rutland Brewery.

Their brewery, at 5 Barnby Gate, grew out of the Rutland Arms Hotel, run by John Wallis in 1869 (then listed at the Portland Arms Hotel) and by Robinson & Co. of Sheffield between 1872 and 1881, trading as Rutland Brewery Company to 1883. Henry Jessop was the next owner until 1887, trading as Jessop & Hopewell.

In 1890 Jessop withdrew; brewing appears to have ceased in 1891. The Newark Brewery Company was then formed, later merging with Robinsons, Sheffield, to form Newark & Sheffield Breweries.

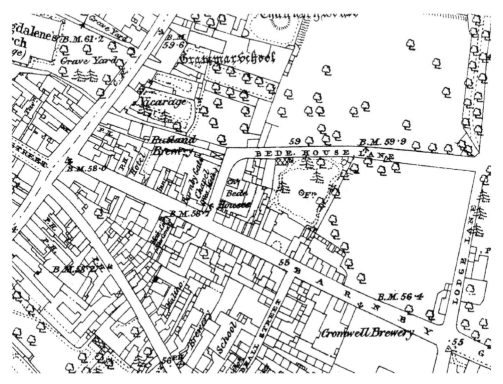

OS map, *c.* 1885, showing Rutland and Cromwell breweries.

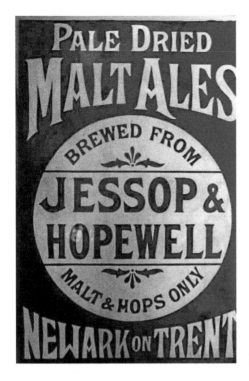

Enamel sign.

93,582. All Beers included in Class 43.
JESSOP & HOPEWELL, Newark-on-Trent;
Brewers.—1st November 1889.

The firm registered their
New Ark trademark on
1 November 1889.

1897: Thomas Stones, Home Brewery, Monument Street, Peterborough

1897: Alfred M. Eadon & Co. Ltd, Plant Brewery, Doncaster
(at least sixteen pubs)

1905: Morris' Rutland Brewery Co. Ltd, Rutland Brewery, New Street, Oakham
(for £28,250 and twenty-two pubs)

1911: Alma Brewery, Cambridge

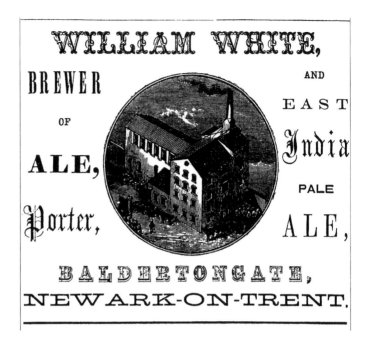

White's Brewery
advertisement, 1865.

1919: W. S. Davy, Devon Brewery, Balderton Gate, Newark

The brewery, fronting Balderton Gate and Barnbygate, was established in 1862 by
William White of the Royal Oak, Castlegate, where brewing had commenced. He
supplied his own beer for the public houses and the private trade, and bottled Guinness.
On White's death, the business was continued by his widow, Dinah, who transferred
the bottling of Guinness back to the Royal Oak.

In 1883, John Goodwin, managing partner at Caparn and Hankey's Castle Brewery,
took over the lease of the brewery, placing its management in the hands of his sons,
Fleming and William, trading as Goodwin Bros. Production rose from 3,981 to 12,273
barrels in seven years. The brewery was altered in 1886 to Martin & Hardy's designs. In
February 1891, Goodwin Bros Ltd was formed with a value of £40,560, an annual profit
of over £8,500, and twenty-eight pubs and dwellings. New offices opened in Barnby
Gate. In 1893, the firm registered its trademark: a generic oval label with a spade motif.

Their beers received praise:

Imperial Invalid Stout – 'fine flavour and rich quality';
Mild Beer – 'brilliant, with a golden-brown colour and a full palate';
Bitter Ales – 'fine and sparkling like champagne';
Country Ale or AK – 'beautiful light luncheon ale, brewed from the finest pale malt
with fine East Kent, Worcester and Farnham hops';
East India Pale Ale – 'brewed from the finest pale malt'.

In 1898 the brewery was purchased by Walter Shirley Davy, manager of James Hole's
Castle Brewery. He renamed the building the 'Devon Brewery' (pronounced Deevon),
after the nearby river.

The Brewery, 1891.
(*Newark Advertiser*)

In 1899, Davy bought Vale Brewery of Langar Lane, Harby, which was established around 1880 by William and Samuel Furmidge, and acquired by Edward Oakden, Dolphin Brewery, Nottingham, 1895.

Davy became a W&R director for two years, leaving to become chairman and managing director of Truswell's Brewery, Sheffield. Some Devon Brewery buildings were afterwards used as stables for dray horses, but brewing equipment remained until the 1950s.

1924: McGeorge & Heppenstalls Ltd, Albion Brewery, Newark

Christopher Heppenstall was engaged in the brewery trade before establishing the Albion Brewery in 1847, on land between Balderton Gate and William Street. The Eagle Tavern was also built, and other pubs were bought – e.g., The Black Horse; Victoria Inn; Marquis of Granby; White Horse, Newark; Plough Inn, Egmanton; and Wheatsheaf, Farnsfield. Trading as C. Heppenstall & Company until 1872, when he died, the brewery passed to nephews Christopher and the Rev. Frederick Heppenstall. Frederick then sold his share in the brewery and the Eagle Tavern to Christopher for £1,500.

Christopher Heppenstall died in 1886; his sons, Harold Wood and Christopher, traded as Heppenstall Brothers, becoming Heppenstalls Ltd in 1887.

The company joined with McGeorge & Sons to concentrate on wine and spirits, trading as McGeorge & Heppenstalls Ltd. Brewing ceased in 1892, with Warwicks supplying their beer.

1955: Brampton Brewery Co. Ltd, Brampton, Chesterfield
(with around 116 pubs)

1955: Smith & Co. (Oundle) Ltd, North Street, Oundle
(with eighty-three pubs; brewing ceased 1962)

Warwicks and Richardsons were bought by John Smith's Tadcaster Brewery Ltd in 1962 and ceased in 1966.

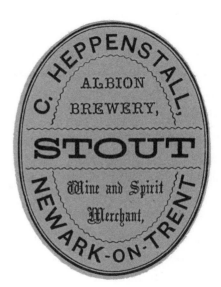

Heppenstall advert.

Heppenstall's label, pre-1887. It also had bottled ale and draught XXXX Ale, XX Ale, X Ale, A1 Light Dinner Ale, and stout. (Author)

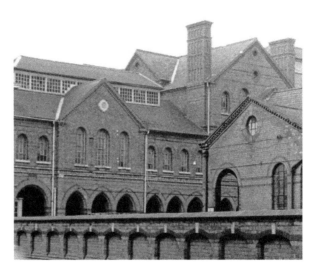

Northgate Brewery. (Frank Baillie)

Worksop & Retford Brewery Co. Ltd

The Prior Well Brewery Co. was established at Priorwell Road/Kilton Road, Worksop, in 1861 by local timber merchant Joseph Garside and Daniel Fossick Alderson. In 1881, Alderson died while duck shooting by the River Poulter near the Normanton Inn, Clumber. The brewery used water from the well associated with Worksop Priory; the monks 'wrought miraculous cures' from the water's properties.

In 1881, the company amalgamated with Smith & Nephew, Cresswell Holme Brewery, Worksop, to form Worksop & Retford Brewery Co. Ltd, with Joseph Garside as president and William Allen as managing director.

The Cresswell Holme Brewery, Dock Road, Worksop, adjacent to the Chesterfield Canal, was founded by Robert Wood-Smith before 1862; he was joined in 1871 by his nephew, William Allen, trading as Smith & Nephew.

They also ran the Old Brewery, 61 Carolgate Bridge, East Retford, purchased before 1876. Hodgkinson & Co. had brewed in 1855, with Thomas Hodgkinson running it by 1862.

Around 1881, Smith & Nephew had also acquired the Southwell Brevery Company at, or near, The Admiral Rodney, King Street, Southwell. The Irishman George Langtry was manager in 1881. John Dixon, followed by his wife Elizabeth, had previously brewed.

Above left: Memorandum, 1879, showing Cresswell Holme Brewery and Old Brewery, Retford.

Above right: Former Old Brewery, 1926, used by chemical manure manufacturers. (Bassetlaw Museum)

After amalgamation, all brewing was done at Priorwell Brewery. The Old Brewery was initially retained, but was then sold to Birkett & Co. Ltd, chemical manure manufacturers, who were still trading in 1926.

Smith & Nephew's trademark was an oak tree surrounded by oak leaves – the Worksop emblem. The new company combined the oak tree and an iron cross – an emblem reflecting health. Thomas Salt & Co. Ltd of Burton-on-Trent also used the emblem.

Pubs were owned in Worksop, Retford, Tuxford, Whitwell, Blyth, Edwinstowe, Wickersley, Maltby and Haggerfield in the counties of Nottingham, York and Derby.

Joseph Garside died in 1893, when a brewery advertisement showed thirteen draught beers – X, XX, XXX and XXXX mild, B, BB, BBB, IPA pale, S, DD, DDD strong and XP, XXP stouts. They also brewed – in October and November, especially for Christmas – Strong Mild Ale (DDDD or 'Donovan', named after the sixth Duke of Portland's celebrated racehorse and winner of eighteen races, including the Derby, 1889). Donovan continued to be brewed and achieved a diploma at the 1955 British Bottlers Institute Competition.

Other awards won included a second-prize silver medal in 1913, with a second in 1914. Priorwell Prize Stout in bottle – 'the Cream of Stouts' – gained gold and silver medals in 1952 and 1954 at the Brewers' Exhibition. 'Priorwell' was registered as a trademark in early 1951.

Don Jon in bottle (pale in colour and believed to have been named after the racehorse that won the St Leger in 1838, owned by George Stanhope, Earl of Chesterfield) won a gold medal in 1955. A pub in Maltby had the same name.

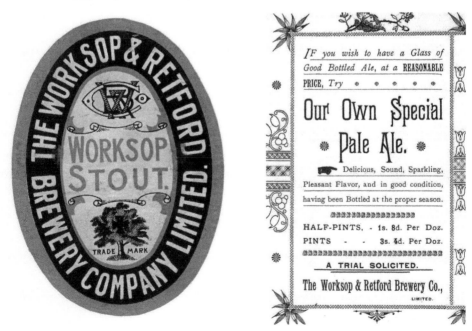

Above left: Early Stout label – before Priorwell. (Author)

Above right: Advertisement (firm's almanac, 1893).

Dundee, bottled nut brown ale, won silver in 1954. Later, this was simply called Nut Brown Ale. There was also a bottled pale ale (before 1900 apparently called Special Pale Ale); Worksop Stock XX Porter, which 'will compare favourably with the best brands of London, Burton, and Dublin'; Worksop Bitter and Worksop Best Bitter.

William Allen died on 9 November 1913, with sons Robert Henry Allen, managing director, and William Reginald Allen, engineer, inheriting his estate. R. H. Allen died in 1939.

Acquisition
1939: Old Albion Brewery Ltd, 69/71 Eccleshall Road, Sheffield
(with fifty-two pubs)

Brewing ceased in 1950, the premises being sold to a firm of toolmakers. Originally founded around 1840 and run by William Jepson, it was purchased by Frederick Hunt in May 1846, later being joined by William Fernell and Joseph Warhurst, the firm owning at least sixteen pubs.

In July 1873, Weyland Latham and Basil Quilhampton bought the brewery, which was resold to S. H. Ward & Co. Ltd in 1876, together with Bradley's Soho Brewery next door, becoming Wards Sheaf Brewery. Wards sold the Albion Brewery in November 1877 to Peter Lowe, who ran it with his partner Daniel Henry Coupe and company until 1882, when Lowe sold his interest to Coupe. The Old Albion Brewery Company Ltd was formed in 1888. A Waitrose car park and an adjacent property now cover the site.

W&R was bought by Tennant Bros Ltd of Sheffield in 1959 with 192 pubs. Brewing ceased at Worksop in 1960 and the brewery was demolished in 1962. Tennants continued to brew Don John Ale at Sheffield to 1963.

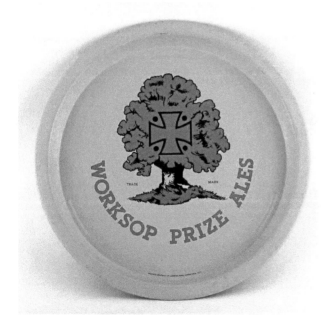

Brewery tray. (Richard Percival)

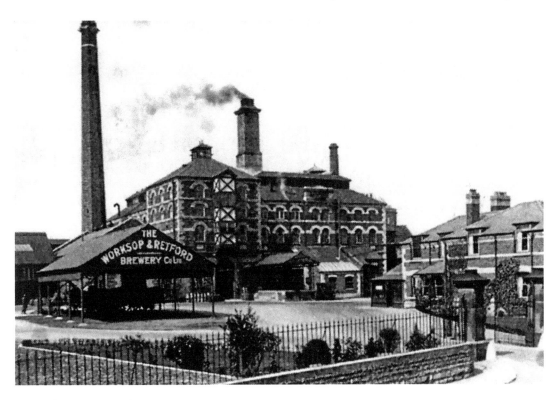

Above: Priorwell
Brewery.

Right: Worksop &
Retford pub.

Nottingham Home Brew Pubs

My research revealed over 400 home-brew pubs in the city. This section of the book – in note form – selects just twenty-five of these, illustrated mainly by *Goad Insurance Map* extracts, showing positions of brewhouses.

Barleycorn, 43 Raleigh Street, New Basford
Alfred Lees 1877
Thomas Bradley 1895 (later at Midland Brewery).

Blue Ball, 7 Peck Lane
Joseph Perry 1832;
John Rayson 1885;
Christopher Rayson 1894–98.

Cricketers Arms, 55/57 Brown's Croft, Old Basford
Established 1853 – beer matured in rock cellars;
Mrs Elizabeth King 1902–1910;
Frances M. Tomlin 1922;
Matthew Tomlin 1921–1926;
Cyril Wilkinson to 1930, when ceased.
A stone jar exists with Stephen Morley's name on it (date unknown).

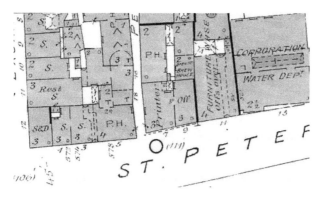

Blue Ball.

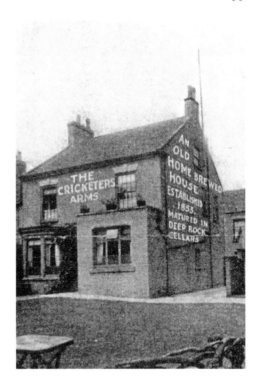

Cricketers Arms, Basford. (Ian Peaty)

Cricketers Arms, 154 Alfreton Road
John Flinders 1877;
Thomas Bradley 1881 (brewer Edward Stokes, and son Thomas Losco Bradley – later at Midland Brewery);
John Bradbury 1884;
Frank Moult 1887–1892;
Aaron Aldred 1895.

Fishermen's Rest, 38 Alfreton Road
Mrs Mary Hooke 1898.

Fox & Crown, 286 Alfred Street Central
John Green 1884–1906;
Thomas Herbert Holland to 1910;
Mrs Rebecca Cass to 1926;
Albert Holland 1935–1940.

Fox & Crown, 33 Church Street, Old Basford
John Hartley 1877;
Mark Faulconbridge 1881–1887;
Mrs Henry Patching 1892;
Elizabeth Woolley 1895;
Joseph Smith 1898;
Brewing reintroduced – now home to the Alcazar Brewery.

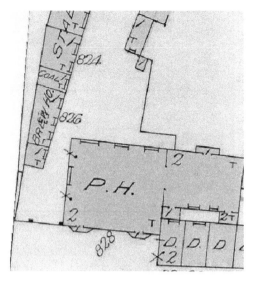

Fox & Crown, Old Basford.

Gate Hangs Well, Brewhouse Yard, Castle Road
Richard Savidge 1877 (when The Gate Inn);
Nathan S. Woodward pre-1900.

Hand & Heart, 65/67 Derby Road
George Burnadier 1898–1902;
James Lewis 1926–1935.

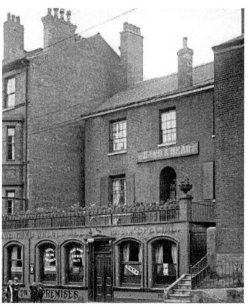

Above left: Closed 1906; demolished.

Above right: Hand & Heart with home brew sign.

Mansfield Arms, 20 Mansfield Road
John Turner 1877–1884;
Mrs Sarah Fisher 1884;
Sarah Ann Turner 1887;
Mrs Sarah Ann Watchorn 1892;
John Brown to 1895;
John Marshall 1898;
John Newstead 1898–1922.
Still trading in the 1950s, when a Shipstones house.

Miltons Head, 98 Derby Road
Goad Insurance Map shows a brewhouse here – however, by the time of the compilation of the map, it may have been part of Wollaton Works.

New George, 22 Warser Gate
Robert Jerram 1877;
George Bausor 1892–1895;
Thomas Bannister (exors of) 1898–1906;
Thomas Bannister Jr to 1906;
Benjamin James Smedley to 1910;
Albert Webster to 1920.
By 1922, Trust Houses was running the pub.

Noah's Ark. 32–34 Coalpit Lane, St John's Street
William Cooper 1884–1895;
William Graham to 1898;
George Graham to 1902;
John Truswell 1906–1914;
John Henry Frettingham 1921–1923.

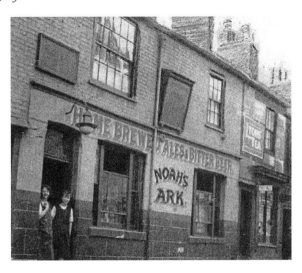

Noah's Ark.

THE ADMIRAL DUNCAN
Coal Pit Lane
Landlord= = =Mr. Reuben Ferrin,
Where you can have one of the Best Cans of Genuine
Home-brewed Ale in the neighbourhood.　Mr. R.
Ferrin is one of our most noted local Ornithologists
in Nottingham. A great number of Prize-Bred Cana-
ries for the Visitors inspection or sale.

c. 1900.

Old Admiral Duncan, Coalpit Lane, St John's Street
Reuben Ferrin, brewer 1884–1902 and also ornithologist advertising canaries for
inspection and sale;
Joe Goode 1906–1914;
Edgar Lama Brooke 1921–1923.

Old Peacock, 136 Ilkeston Road
George Brooks 1885;
Archibald Brooks 1895;
Mrs Clara Brooks to 1914;
William Archibald Brooks to 1923.

Porters Rest, 2/4 Cromford Street
John Wilson 1921–1923;
Harold Winterbotham 1926;
Ellis Sidebottom to 1930;
Edward A. Lanes to 1935.

Postern (Old Postern) Gate, Drury Hill/Middle Pavement
Thomas Butler 1877;
Charles William Curwood 1891/2;
William Winfield 1895;
William F. Oakland 1898–1906;
Demolished 1911.

Sawyers Arms, 2 Greyfriar Gate
William Bezant to 1877;
Frederick Goodwin Whitby *c*. 1882–1887;
Thomas Shaw 1892;
William Campion to 1895;
Mrs Eliza Grundy to 1898;
John Harper 1898;
Oliver Redgate 1902–1914;
George William Render 1921–1923.

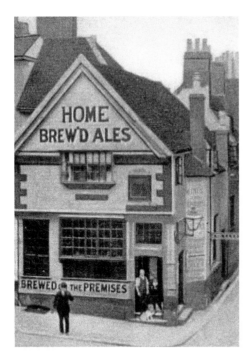

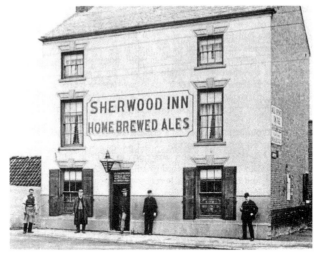

Above left: Home brewing advertised, *c.* 1891 – Postern Gate.

Above right: Sawyers Arms.

Right: Sherwood Inn *c.* 1890 (*The Inns and Pubs of Nottinghamshire*).

Seven Stars, 25 Platt Street/Union Street
George Carlisle 1895–1898;
Jacob Underwood 1902–1921;
John Underwood to 1923;
Robert Edward West to 1926.

Sherwood Inn, Mansfield Road/Lloyd Street, Sherwood
Built in 1840s;
Leeson B. Wilkinson 1892–1910;
Thomas Banner Wilkinson 1914–1920.

Tiger's Head, 109 Narrow Marsh
Henry Hodges 1884.

Town Arms, Malin Hill, Plumptre Square
Founded before 1758.
James Poxon 1877;
John Pilkington 1884–1892;
Mrs Elizabeth Poxon 1895;
Charlie Clarke 1926–1940.

Town Arms, 318 London Road
John Henry Mettam 1892–1906;
Bought by Nottingham Brewery before 1944; sold by Whitbread 1977;
'Home Brewed Ales' signs displayed on the wall.
Renamed 'The Aviary' in 1985; now 'Riverside Bar'.

Union Inn, 830 London Road
Mrs Catherine Gill 1891.
Rowing club later occupants.

White Horse Inn, 313 Ilkeston Road, Radford
Former coaching house, rebuilt in 1912;
Thomas Vickers to 1877;
Mrs. Sarah Vickers to 1884;
Samuel M. Hobkin 1887–1895;
H. Edward Hopkins to 1898;
William H Tomlin 1898–1914;
Mrs. Mary Edith Tomlin 1921–1926.
Later Shipstones house, now a café.

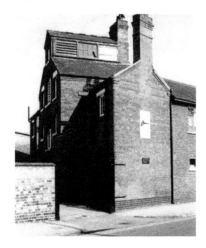

White Horse Brewhouse.

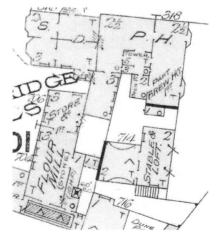

Town Arms, Trent Bridge.

Ye Olde Trip to Jerusalem, 1 Brewhouse Yard, Castle Road

Reputed to be the oldest home-brew inn in England, it was established in 1189 but the foundations date back to 1070, two years after the erection of Nottingham Castle for William the Conqueror. Originally supplied beer for the king and his estate.

It was known as 'Ye Olde Trip' from 1799 at least; it was previously known as 'Trip to Jerusalem' and, earlier, as 'The Pilgrim' – where crusaders stopped for rest and refreshment en route to the Holy Land.

Brewhouse Yard contained a brewhouse and malt kiln for the use of the garrison. Barnard stated: 'In 1621, James I withdrew it from the Castle jurisdiction and granted it to Francis Phillips, gentleman, and Edward Ferres, mercer, both of London'.

It was owned by William Stanford in the mid-1700s. Malting was undertaken in the Rock Lounge, with brewing underneath. It continued as a free house to *c.* 1990, when bought by Hardy Hansons, Kimberley.

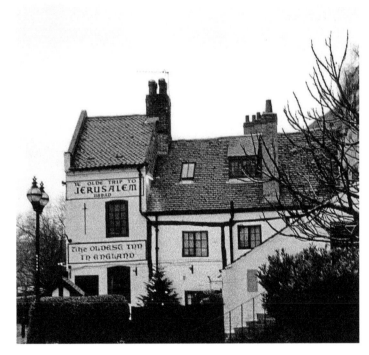

Above left: Home-brewed beer produced to *c.* 1939 – some of it bottled.

Above right: Ye Olde Trip – still trading.

Notes on Selected Other Breweries

Nottingham:
Alfreton Road Brewery, Radford
Thomas Bailey 1841–1855 (also *Nottingham Mercury* proprietor). Stores – 7 Maypole Yard.
Baker & Todd 1857/8;
Francis Joseph Baker 1860.

Forest (Bulwell) Brewery, Bulwell Lane (Highbury Road), Bulwell
John Perry 1844.
John Perry & Son 1848–1868 (Forest Brewery);
Stores at Bromley House, 13 Angel Row, Nottingham;
Richard Jennison 1876–*c.* 1880. Had kept the Horse Shoe 1858;
Jennison & Co. 1885 (Alfred Jennison brewer 1881);
Richard Myrtle, and Tom Harwood 1891 (Church Knell Brewery). Ceased 1892;
Demolished *c.* 1900 – Coopers Club/houses on site.

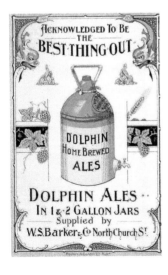

From *Time Gentleman Please*. (Mike Jones)

Forest Brewery, 302 Alfreton Road, Radford
Erected in 1884 by Duncan, King & Co. Offered for sale in 1888 with seven pubs. Site is now houses.

Dolphin Brewery, 6–10 North Church Street
Samuel Pogson *c.* 1877–1887;
Edward Oakden *c.* 1892;
William S. Barker 1895–1898;
Barker & Company 1898–*c.* 1900.
Claude Septimus Mawby *c.* 1904–1906;
The Dolphin Brewery Co. to 1907 – offered for sale with six pubs;
Rebuilt. Owned by Shipstones; demolished *c.* 1971.

Burton Joyce:

Cross Keys Inn Brewery, Main Street
Inn over 300 years old;
John Hogg brewer 1877–1887 (also butcher and wicket keeper, Nottinghamshire Cricket team);
William Doughty 1904;
'Home brewed ales' sign at first-floor level (occupier Arthur Cragg);
Later a Nottingham Brewery pub.

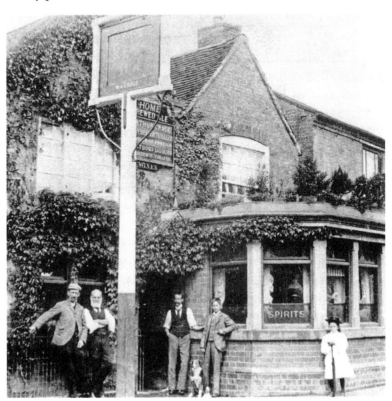

Cross Keys, *c.* 1910.

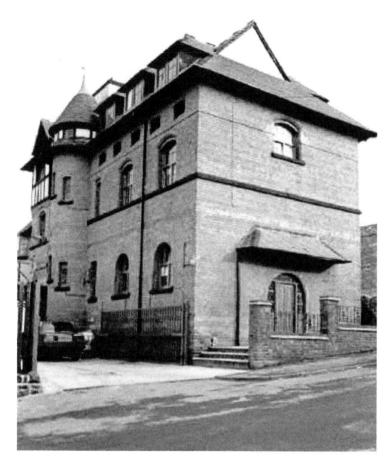

Carlton Brewery's building was converted and is now residential.

Carlton:

Carlton Brewery, Marhill Road/Primrose Street
Brewery built in 1899 by Nottingham architect Watson Fothergill;
Originated from William Vickers' business, The Black's Head;
Mrs Catherine Vickers 1902;
William Vickers (possibly son) at the brewery from 1904 to 1906;
Offered for sale in 1904, 1906 & 1909.

Everton:

Farmers' Brewery Co. Ltd, Brewery Lane
Tune & Johnson to 1877;
John S. & Edward M. Edwards to 1884;
Thomas Edward Johnson 1885;
Parkinson, Chambers & Co. to 1890;
Mark Parkinson (a farmer) to May 1894, when above company registered;
William Henry Ottley, manager 1900–1904.
Ceased and sold to Whitworth Son & Nephew Ltd March 1907;
Owned Angel Inn, Blyth.

Gamston:

Newcastle Brewery, Muttonshire Hill

Robert Moody Wilson (born Ollerton, 1856) ale and porter brewer and bottler, maltster and hop grower (residence – Oak House, Gamston) 1881–*c.* 1885;
Maltings at Ordsall and property at Tuxford;
Brewery demolished but house remains (a Grade II listed building).

Langar:

Unicorn's Head Inn Brewery, Main Street

Built 1717 (formerly The Feathers*)*.
Robert Simon to 1732;
Mary Scothern 1876,
Thomas Halliday 1881;
John James 1904.

Radcliffe:

Radcliffe Brewery, Walkers (Brewery) Yard

Butler Parr, brewer/maltster 1855, inherited premises from his father, Richard Parr, who was a cricketer. His daughter Mary married Richard Daft, born in Nottingham in 1835 – he was captain of Nottinghamshire Cricket Club 1871–1880, and also played for England. Daft was taken as partner, creating Parr & Daft.

Parr died in 1872, and the brewery was run by Richard Daft to beyond 1887, although he remained an agent for Samuel Allsopps, Burton-on-Trent in 1891. The Daft family lived in The Rosary – the cellar was used for beer storage.

Walkers Yard, Radcliffe, showing The Rosary and former brewery buildings. (Val Cook)

Daft was a brilliant cricketer, but a hopeless businessman; he also ran a Nottingham sports shop, but business deteriorated. He was once landlord of The Trent Bridge Inn, but became bankrupt by July 1900. After Richard's death, his widow left for Wales and Home Brewery owned the property (Butler Parr II had become ale and porter agent for Home).

The Rosary was bought from Home Brewery by Mr and Mrs Roberts, who built Number 4 in the garden. The Radcliffe Scouts (founded 1924) eventually moved to The Rosary. Brewery House still stands at the top left of the yard, but the building is now offices.

Royal Oak P. H. Brewery, Main Street
Mrs Sarah Fryer 1874–1881;
Robert Hallam 1881–*c.* 1885;
John Fryer, 1891–1930 (moved from The Black Lion*)*.

Southwell:

West Gate (or Trent) Brewery, West Gate
William Taylor to *c.* 1877 – known as the West Gate Brewery;
Sprigg & Henry by 1884;
S. F. Henry & Co. 1887 (Thomas Dixon brewers' manager and J. Frank Hunt brewer);
By 1891, the brewery was inoperative, but John Thomas Wright traded as a maltster, and an ale, porter, wine and spirit merchant, West Gate;
Herbert Fawsit Ealand, brewer *c.* 1899;
Business bought by J. Marston Thompson & Son Ltd, Burton-on-Trent, 1904, with ten pubs.

EALAND

223,532. Fermented Liquors and Spirits. HERBERT FAWSIT EALAND, The Brewery, Southwell Nottinghamshire ; Brewer.—1st June 1899.

Trademark registration, 1899 (Ealand – type of gazelle).

HERBERT F. EALAND

THE BREWERY,

SOUTHWELL.

WINE AND SPIRIT MERCHANT,

MALTSTER,

Agent for Ind, Coope & Co.'s Noted Burton Ales.

Bottler of Bass' Ales and Guinness' Stout.

Right: Advertisement, *c.* 1900. Ealand was an Ind Coope agent and bottled Bass and Guinness.

Below: Westgate Brewery premises after Marston's takeover.

⤝ *CASK ALES* ⤞

From 10d. to 1/6 per Gallon.

[40B]

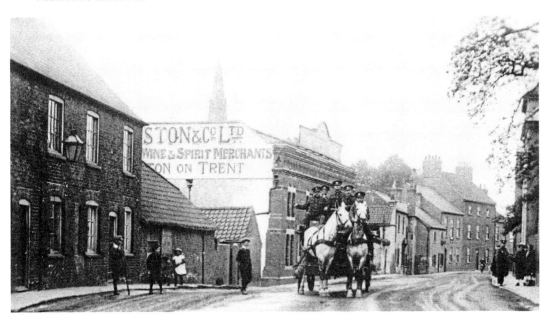

Sutton-in-Ashfield:

Crown Brewery, Alfreton Road

William Holdsworth Walton – ale and porter merchant, Church Street 1876/77;
Holdsworth innkeeper, The Durham Ox, Market Place, 1881–1885;
Crown Brewery opened 1892 (designed by Mr McBishop, Sutton-in-Ashfield, with plant by H. J. West & Company);
W. H. Walton & Co. to 1900;
William Walton at Crown Brewery to 1898;
James Graves & Co. 1904 (brewers, bottlers, mineral water manufacturers, wine and spirit merchants);
Crown Brewery Co. to 1906;
Owned The Shoulder of Mutton, Wymeswold.
Brewery demolished.

Durham Ox Inn Brewery, Market Place

Mrs Mary Clarke 1876/77;
William Holdsworth Walton 1881, after running ale and porter merchant's business in Church Street – he built Crown Brewery 1892.

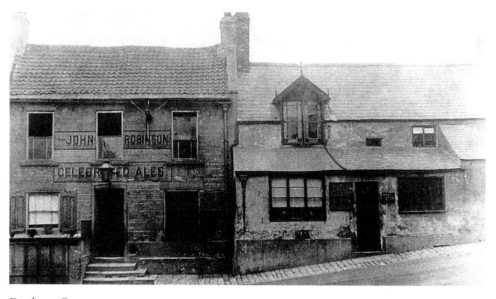

Durham Ox.

The Modern Micros

Over fifty microbreweries have been established in Nottinghamshire, with some still trading. Most have pump-clip illustrations.

Abbey Brewery, founded at Stainton, South Yorkshire by David Mullins in 1981. It moved to Unit 1, Daneshill Road, Torworth in 1982. Brewing ceased in 1983 when Peter Amor bought the brewery. David Mullins moved to Cropton Brewery. In 1985, Peter Amor relocated to The Nags Head, Canon Pyon, Herefordshire, starting Wye Valley Brewery.

Alcazar Brewery was established at the Fox and Crown, 33 Church Street, Old Basford, virtually opposite the former Hutchinson's Prince of Wales Brewery. In autumn 1996 it was trading as Fiddler's Ales, with Harvey Gould as brewer, assisted by Roger Nowill, landlord.

In August 1999, the pub was purchased by David Allen, a chemical engineer, who commenced brewing trials in October with co-brewer Jon Pilling, under the style of the Alcazar Brewing Company.

Beeston Hop Ltd was started commercially by John Richardson, a home brewer, at 17 Gwenbrook Avenue, in 2015 on a small plant at his home, mainly producing bottled conditioned beer.

Abbey Brewery
Traditional Malt Ales

BEST BITTER

O.G.

Telephone: Rotherham (0709) 815160

Abbey Brewery label.

Fiddlers Ales clip.

Alcazar clip.

Black Iris Brewery, founded at The Flowerpot, Derby, on 1 August 2011 by Alex Wilson, Nicholas Solkard (both brewers) and Jim Grundy. It moved to Unit 1, Shipstone Street, New Basford in 2014.

Black Market Brewery, 43 High Street, Warsop, is a small 2.5-barrel brewery established by David Drury and Kenneth Ward in the cellar of the Workmans & Black Market Venue – a bar and music centre – in December 2015.

Black Iris clip.

Black Market Brewery clip.

Blue Monkey Brewing Ltd moved to 10 Pentrich Road, Giltbrook Industrial Park, Giltbrook, in 2010. Established by John Hickling and Trevor Vickers, it first brewed in September 2008 at 1 Enterprise Court, Manners Avenue, Manners Industrial Estate, Ilkeston.

The brewery owns four pubs – three called The Organ Grinder at Alfreton Road, Nottingham, Woodgate, Loughborough, and Portland Street, Newark-on-Trent, and The Coffee Grinder, Arnold.

Bramcote Brewing Company at 236 Derby Road, Bramcote, was started by Philip and Peter Darby and Niven Balfour, caterers and keen home brewers, in an old farmshop on 8 January 1996.

In 1997, they moved their operation to Queens Bridge Road, Nottingham and renamed the business the Castle Rock Brewery.

Broadstone Brewery Co. Ltd was founded by Alan Gill at Lodge Farm Industrial Estate, Ash Vale Lane, Tuxworth in September 1999, with Steve Pendered and Richard Osborne. Alan had left Springhead Brewery, Sutton-on-Trent. They moved to outbuildings at the rear of The Rum Runner, Wharf Road, Retford, in spring 2001, supplying the pub and free trade, producing a range of cask and bottled beers. Brewing ceased in 2006.

Castle Rock Brewery was established next to the Vat and Fiddle, Queens Bridge Road, Nottingham, in 1997 by Philip and Peter Darby and Niven Balfour, when they moved their operation from the Bramcote Brewery, changing the name. Tynemill Inns bought a 50 per cent stake.

The brewery supplies Tynemill Inns houses and has a considerable free trade. In 2001, Philip and Peter Darby and Niven Balfour left the brewery when their 50 per cent stake was bought by Tynemill, setting up their Nottingham Brewing Company, Radford.

GUERRILLA is our multiple award winning, revolutionary stout. Voted the best beer in the Midlands and the best stout in the UK. A hearty, pitch black beer full of malty complexity balanced by a robust bitter bite.

This is a bottle conditioned beer, so there will be a bit of harmless and natural yeast sediment. It's supposed to be like that!

4.9% A.B.V
Best Before: 01/02/2013
500ml ℮
Produced by Blue Monkey Brewery, Giltbrook, Nottingham. NG16 2UZ
www.bluemonkeybrewery.com

blue monkey brewery

GUERRILLA

Blue Monkey beer.

Bramcote Brewing clip.

Broadstone Brewing label.

Caythorpe Brewery – in a store behind the 300-year-old Black Horse Inn, 29 Main Street, Caythorpe – was started in May 1997 by Geoff Slack, former engineer at Home Brewery, Daybrook. This was with his wife Pam, and Sharon Andrews, pub landlady. In 2005, Geoff and Pam Slack retired from the brewery, which was bought by John Stachura.

Castle Rock clip.

Caythorpe Brewery clip.

Copthorne Brewing Company was started in September 2010 at the Nags Head, Old Great North Road, Sutton-on-Trent by Dean Penney, who was formerly of Milestone Brewery. It was relocated in 2011 to Majors Farm, Woodcotes Lane, Darlton, Newark, but ceased in 2015.

Crown Brewery, at George Street, Newark, was founded by Norman and Alan Rutherford, in former maltings in November 1977, trading as Westcrown Ltd. Brewing started in 1978, supplying Regal Bitter and Conqueror to their own public houses and the free trade. In 1979, the business became Westcrown Breweries Ltd. Brewing ceased in 1980, mainly because of debts owed by the National Wine and Distillery Stores, purchased in 1978.

The premises and equipment were bought for £10,000 by John Shields, owner of the Priest House Hotel, Castle Donnington, in December 1980. It then traded as the Priory Brewery, selling beers at the hotel until July 1983. The company went into liquidation a month later.

Double Top Brewery – founded in 2011 by the licensee of The Mallard pub, Wayne Cadman. It traded from the pub at Worksop railway station until 2012, when it moved to 4 Kilton Terrace.

Copthorne Brewery clip.

Left: Westcrown label.

Below: Priory Brewery label.

Double Top clip.

Dovecote Brewery clip.

Dovecote Brewery traded from mid-2001 to 2002 from The Old Ale House, Top Street, Elston. Nathan Gale, former police detective, set up Nathan's Fine Ales using a small plant in an old dovecote behind a private house. He supplied the local free trade, especially the Fox and Crown, Newark. He ceased owing to ill health.

Dukeries Brewery Ltd – started by Phil Owen and Phil Longley in November 2012 – is located at Pepper's Warehousing Unit, Carlton Forest Distribution Centre, Blyth Road, Worksop.

Fellows Morton & Clayton Brewhouse at 54 Canal Street, Nottingham. A brewpub started by Whitbread in December 1981 and named after a canal transporting company. In 1996, it was owned by Les Howard, and Dave Willans, brewer. They later ran The Southbank Bar, West Bridgford and The Globe, London Road, ceasing in 2008.

Dukeries Brewery clip.

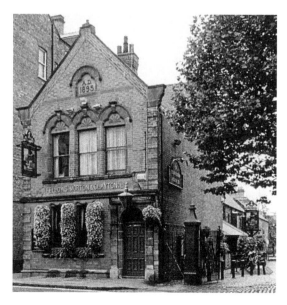

Fellows Morton & Clayton Brewhouse.

Flipside Brewery at Unit 3, East Link Trading Estate, Private Road 2, Colwick Industrial Estate, Colwick, was started by Andrew Dunkin in May 2010, with a range of draught and bottled beers. The Old Volunteer, Carlton, and The Golden Fleece and Lord Roberts, Nottingham, are operated.

Full Mash Brewery, at 17 Lower Park Street, Stapleford, was founded by Karl Waring in August 2003, brewing in his kitchen and an adjoining outhouse using a quarter-barrel plant – upgraded several times.

Flipside clip.

Full Mash label.

Funfair Brewing Company was founded by David Tizard in March 2004 at The Wheel Inn, Chapel Street, Holbrook, Derbyshire. Brewing stopped following the sale of the pub; the brewplant was removed in December 2004, reopening at 34 Spinney Road, Ilkeston, during March 2005. It relocated again to Canal Street, Ilkeston, in September 2006, and finally moved (2012) to The Chequers Inn, Toad Lane, Elston, Newark (owned by the brewery), installing a larger plant.

Grafton Brewery, at The Packet Inn, Bescoby Street, Retford, was started by John Allcroft in the former stables and hayloft at the rear in March 2007; before then, Grafton beer was contract brewed. The brewery moved to Unit 5, Peppers Warehouse, Blythe Road, Worksop at the start of 2011 before moving again in spring 2014 to Unit 4, Claylands Industrial Estate, Worksop.

Hales Brewery trade from Unit 5, Peppers Warehouse, Blythe Road, Worksop, and was started by Suzi Hale in 2014 after Grafton Brewing Co. had moved.

Handley's Brewery, founded by pub owners Kathryn and Brett Handley in summer 2011 at their pub Willow Tree, Front Street, Barnby-in-the-Willows, supplies the pub and the free trade with draught beers such as Barnby Bitter.

Holland Brewery was a tiny brewery – in the shadow of Hardy Hansons – established by experienced home brewer Len Holland in a shed outside the back door of his home at 5 Brown Flatts, Brewery Street, Kimberley in April 2000. A small number of local outlets were supplied. Sadly, Len Holland died in November 2011 and brewing ceased.

Above left: Funfair clip.

Above right: Grafton clip.

Hales Brewing clip.

Handley's clip.

The Idle Brewery was founded at The White Hart Inn, Main Street, West Stockwith by Wayne Moore and Brian Cooper in April 2007 in a converted barn at the rear, on the banks of the River Idle.

Left: Holland Brewery.

Below: Idle Brewery clip.

Idle Valley Brewery Ltd has been trading from 2014 at Barham House, Aurillac Way, Hallcroft Industrial Estate, Retford. It was established by Christopher Lloyd Harrison Hawkes and Guy and Barbara Cheslyn-Curtis, producing draught and bottled beer.

Justice Brewery at 15 Heron Way, Mansfield, was started in September 2012 by Matt Hartshorn and Jason Booth, landlord of The Redgate, Mansfield, using a half-barrel plant. It closed in 2013.

King's Clipstone Brewery, at The Keeper's Bothy, Main Road, King's Clipstone, was started by David and Daryl Maguire, interior designer and postwoman respectively, in December 2012 in a converted workshop at their home.

Idle Valley bottle.

King's Clipstone beer.

Leadmill Brewery, at 118 Nottingham Road, Selston, was founded by Richard Creighton (a brewer of fifteen years standing) in a former pigsty at the rear of his 200-year-old cottage in 1999. In September 2001, he moved his operation to Denby, near Ripley, Derbyshire, but now trades from Heanor.

Lincoln Green Brewing Co. Ltd was founded at Unit 5, Enterprise Park, Wigwam Lane, Hucknall, by home brewer Anthony Hughes in early 2012 and has an extensive free trade, supplying both draught and bottled beers with a Robin Hood theme. The brewery owns The Sir John Borlase Warren, Canning Circus, Nottingham, and The Robin Hood and Little John, 1 Church Street, Arnold.

Leadmill clip.

Lincoln Green clip.

Magpie Brewery Ltd, founded by Bob Douglas and Ken Morrison – former employees of the conciliation service ACAS – and Nick Sewter – former teacher. It was started in June 2006 at 4 Ashling Court, Iremonger Road. Beers have names with bird themes; they own The Crafty Crow, Nottingham.

Mallard Brewery began in September 1995. Philip Mallard, a planning engineer working for BT, and keen home brewer, used a small plant in a shed at his semidetached house at 15 Harrington Avenue, Carlton. In October 1997, Philip left BT and operated the brewery full time, supplying the local free trade with a range of eleven regular draught and bottled beers – all with 'duck' themes. The brewery was bought in 2010 by Alison Jane Ryan, moving to Unit A, Lakeside, Maythorne Hill, Maythorne, Southwell.

Magpie Brewery label.

Mallards clips.

Maple Leaf Brewery, Winthorpe Road, Newark, was set up by Allied Breweries in the cellar of the Maple Leaf, with brewing starting in May 1982 by Philip Beck, producing around fifteen barrels of bitter a fortnight. Brewing stopped in 1986.

Maypole Brewery – named after the giant maypole in Wellow – was established on 31 March 1995, at North Laithes Farm, Wellow Road, Eakring, by Danny Losinski, former British Coal manager. It used an eighteenth-century converted farm building. He purchased a plant and received training from Springhead Brewery. K. P. and F. S. Munro later bought the business; they opened second brewery at Cromwell – the Milestone Brewing Company – in 2004.

Medieval Brewery was founded by James Mansfield, landlord of The Old Moot Inn, Carlton, in March 2012. It was set up in a private garage at Bestwood, producing draught and bottled beers. In August 2012, brewing moved to Home Farm, New Road, Colston Bassett.

Milestone Brewing Company, sited in a former garage on the Great North Road, Cromwell, near Newark, was started in late 2004 by K. P. and F. S. Munro, owners of the Maypole Brewery, Eakring. The first brew produced was Black Pearl Stout, first sold in January 2005.

The Naked Brewer, at The Corner Pin, 75 Palmerston Street, Westwood, was started by Sarah Webster, who learned brewing at Amber Ales, Ripley, in September 2010, mainly supplying that pub.

Above left: Maypole Brewery beer.

Above right: Medieval beer.

Milestone Brewery.

Naked Brewer.

Navigation Brewery Ltd, launched in March 2012 in the old stable block at the rear of The Trent Navigation Inn, Meadow Lane. It was set up by the owners of Great Northern Inns, who operate the pub and several others in Nottingham.

Newark Brewery Ltd was started in an old maltings at 77 William Street, Balderton Gate, Newark, by Will McKeon and Daniel Derry in November 2012, using an eight-barrel plant.

Left: Navigation Brewery clip.

Below: Newark Brewery.

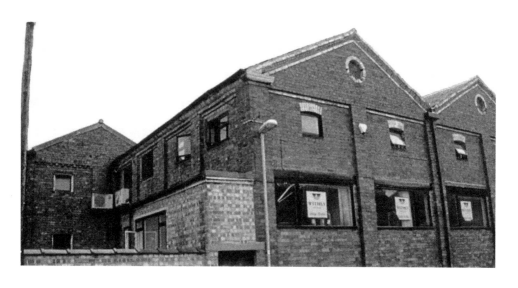

Nomad Brewery was started by Michael Keech, Matthew Weightman and Phillip Roberts – all former archaeologists – at Unit 1, Beggarlee Park, Engine Lane, Moorgreen, Newthorpe, on the site of the former Moorgreen Colliery. It opened in March 2013, but lasted only a few months.

Nottingham Brewery Company trades from buildings behind The Plough Inn, St Peters Street, Radford, being started in October 2001 by former Castle Rock Brewery proprietors Philip Darby and Niven Balfour. It recalls the former brewery of that name in Mansfield Road and uses, on point-of-sale material, designs of the former brewery and the trademark 'Maltanhop'.

Nomad Brewery label.

Nottingham Brewery label.

Pheasantry Brewery at High Brecks Farm, Lincoln Road, East Markham, was established by Mark Easterbrook, who was employed in the food industry for twenty years, on his farm in May 2012. He uses original farm buildings for his brewery and visitors centre (below).

Pickled Pig Brewers began in June 2015 at Unit 5, Staunton Industrial Estate, Staunton-in-the-Vale, using the plant formerly at Copthorne Brewery.

Prior's Well Brewery – founded in July 2010 at The Old Kennels, Clumber Park Estate, Hardwick by Rob Neal and Gary Hobbs as a sister brewery to Maypole Brewery – produced beer from September of that year. Brewing ceased in 2013, but was restarted by Dave Vann and Phil Scotney at Mansfield Woodhouse in 2016.

Pheasantry Brewery.

Prior's Well clip.

Reality Brewery Ltd started at 5B Factory Lane, Beeston on a 2.5-barrel plant in April 2010, but moved to High Road, Chilwell in 2011.

Red Shed Brewery, at 10 Flixton Road, Hollycroft, Kimberley, traded from October 1997 to late 1999. Established by Mike Lynch, home brewer, in a shed at home, he supplied the free trade with beers with 'Red' in their title.

Robin Hood Brewery Ltd was started by John and Fiona Drugan in October 2012, using Wirksworth Brewery's plant. It has used its own plant since September 2013 at Unit 3, Northgate Place, High Church Street, New Basford.

Reality Brewery clip.

Red Shed Brewery clip.

Bendigo Ales Ltd also use this plant. Started in August 2015 by Paul and Lisa Geary, Martin Smith and Nick Ryan with Bendigo Bitter, it features the famous Nottingham prize fighter on its label.

Scribblers Ales Ltd brew at St Apleford Brewery, 7 Lime Grove, St Apleford. Richard Nettleton and Roger Frost started brewing in early 2014, supplying the local free trade. The brewery's micro pub, A Room with a Brew, opened in February 2016 at 78 Derby Road, Nottingham.

Springhead Fine Ales Ltd – named after a River Trent bend – started in June 1990. Alan (previously a BT maintenance engineer) and Yvonne Gill housed the smallest UK brewery at 25 Main Street, Sutton-on-Trent with only 12 square yards. In 1994, they moved to Unit 3, Sutton Workshops, Old Great North Road, with a larger plant, supplying beers with Civil War names; by mid-1996, the brewery was producing fifteen barrels a week for the free trade. However, in June 1997, it went into voluntary liquidation, restarting a month later. Alan Gill left the brewery in 1998, later setting up the Broadstone Brewing Company.

In April, 2011, Springhead relocated to Main Street, Laneham, near Retford. A sister company – Ginger Pig Pubs – owns The Boat Inn, Hayton; The Roaring Meg, Newark; Meg's Bar, The Brewery Tap, Laneham; The Bee's Knees, Laneham and The Bramley Apple, Southwell.

Tom Herrick's Brewery at The Stable House, Main Street, Carlton-on-Trent, was founded by Tom Herrick, who was employed in the quarrying industry, in May 2015 on a small pilot plant in his spare time, after converting two stable blocks at his house. He has supplied beer festivals and a larger plant is being installed to allow supply to pubs from summer 2016.

Tom Herrick's clip.

Totally Brewed Ltd was founded by Rob Witt, first brewing in March 2014 on the former White Dog Brewery's plant, and trading from Unit 10, Meadow Lane Fruit & Vegetable Market, Clarke Road, Nottingham.

University of Nottingham Brewing & Science Research Innovation Centre, Sutton Bonington, houses a one-barrel brewery, built and operated by international brewer SAB Miller – one of the largest microbreweries at any university in the world. It has produced ESB – Extra Sustainable Beer in bottle at 4.5 per cent ABV.

Welbeck Abbey Brewery has traded from Lower Motor Yard, Welbeck Estate since 24 March 2011 – a joint venture between Kelham Island Brewery of Sheffield and Welbeck Estates Company, with Robin Brown and initially Dave Wickett, directors, and Claire Monk, brewster. As well as selling to the free trade, bottled beers are sold at the Welbeck Farm shop.

White Dog Brewery Ltd, started by Paul Burke, Eamon Lyons and David Winfield, traded for less than a year from January 2013 at Unit 9, Sycamore House, Moorgreen Industrial Park, Moorgreen, Newthorpe.

Wollaton Brewery Company in Gauntley Court, Hyson Green was founded by Paul Rowden, owner of Fresh Skin Beauty cosmetics, in 2013, mainly producing bottled beer.

Totally Brewed clip.

Welbeck Abbey clip.

White Dog clip.

Woolaton Brewery label.

Further Reading

Barnard, Alfred, *The Noted Breweries of Great Britain and Ireland*.
Bristow, Philip, *The Mansfield Brew*.
Brown, Ian, *Nottinghamshire's Industrial Heritage*.
Bruce, George, *Kimberley Ale 1832 to 1982*.
Dobson, Roger, *Southwell Inns and Alehouses*.
Parry, David Lloyd, *South Yorkshire Stingo*.
Pask, Brenda M., *Newark The Bounty of Beer*.
Pearson, Lynn, *British Breweries: An Architectural History*.
Pickersgill, Dave, *The Worksop & Retford Brewery*.
Priestland, Pamela, *Radcliffe on Trent 1837 to 1920 – A Study of a Village in an Era of Change*.
Steer, Chris, 'Losco Bradley's Brewery' in the *Basford Bystander*, 1996.
Wright, Gordon and Curtis, Brian J., *The Inns and Pubs of Nottinghamshire*.
Wydell, Doug, *A History of Wath Brewery and the Whitworths*.

Other resources
Beeston Brewery & Samuel Theodore Bunning – 1846-1928. (Exploring Beeston's History, www.beeston-notts.co.uk/bunning.shtml).
Brewers Journal – 1880, 1890 & 1892.
Census records.
House of Shipstone (1952).
Trade directories.
Trademarks Journal.

Acknowledgements

Thank you to:

Staff at Nottingham and Worksop libraries,
The late Frank Baillie,
Reg Baker,
Bassetlaw Museum,
Val Cook,
Roger Dobson,
Mike Jones,
Nottingham City Council,
Ian Peaty,
Richard Percival,
Pamela Priestland,
Stan Smith,
Gordon Wright/Brian Curtis.